the artist unique

INSPIRATION AND TECHNIQUES
TO DISCOVER YOUR *creative signature*

carmen
TORBUS

**NORTH
LIGHT
BOOKS**

CINCINNATI, OHIO

15 14 13 12 11 5 4 3 2 1

www.fwmedia.com

DISTRIBUTED IN CANADA BY FRASER DIRECT
100 Armstrong Avenue
Georgetown, ON, Canada L7G 5S4
Tel: (905) 877-4411

DISTRIBUTED IN THE U.K. AND EUROPE BY F+W MEDIA INTERNATIONAL
Brunel House, Newton Abbot, Devon, TQ12 4PU, England
Tel: (+44) 1626 323200, Fax: (+44) 1626 323319
Email: postmaster@davidandcharles.co.uk

DISTRIBUTED IN AUSTRALIA BY CAPRICORN LINK
P.O. Box 704, S. Windsor NSW, 2756 Australia
Tel: (02) 4577-3555

ISBN 10: 1-4403-0816-0
ISBN 13: 978-1-4403-0816-1

Edited by *Stefanie Laufersweiler*
Production edited by *Kristy Conlin*
Designed by *Julie Barnett*
Production coordinated by *Greg Nock*
Photography by *Christine Polomsky and Al Parrish*

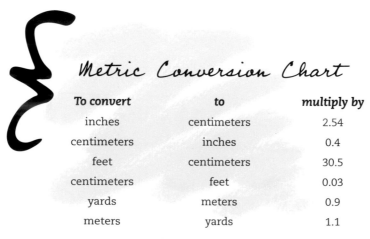

Metric Conversion Chart

To convert	to	multiply by
inches	centimeters	2.54
centimeters	inches	0.4
feet	centimeters	30.5
centimeters	feet	0.03
yards	meters	0.9
meters	yards	1.1

Acknowledgments

To my incredible editors at North Light: Tonia Davenport, Liz Casler and Stefanie Laufersweiler; photographers Christine Polomsky and Al Parrish; designer Julie Barnett for designing my vision; my awesome Support Squad: Katrina Kniep (in the very beginning, when this book was just an idea), and my biggest cheerleaders, Stacie Williams, Haley Ibrahim, Casie Rohde and Stephanie Sharp, for pulling me through; the amazing artists who contributed artwork, ideas and techniques; Dan (my love) and Morgan and Colin (my munchkins): I love you guys so, so much.

Dedication

I believe that signature style is developed through creative discovery and loads of artful play. I would like to dedicate this book to the seeker in *you*. Inside you is an artist with a style all your own. Trust that with a little encouragement and inspiration—paired with easy-to-learn techniques done your way—your creative signature will emerge.

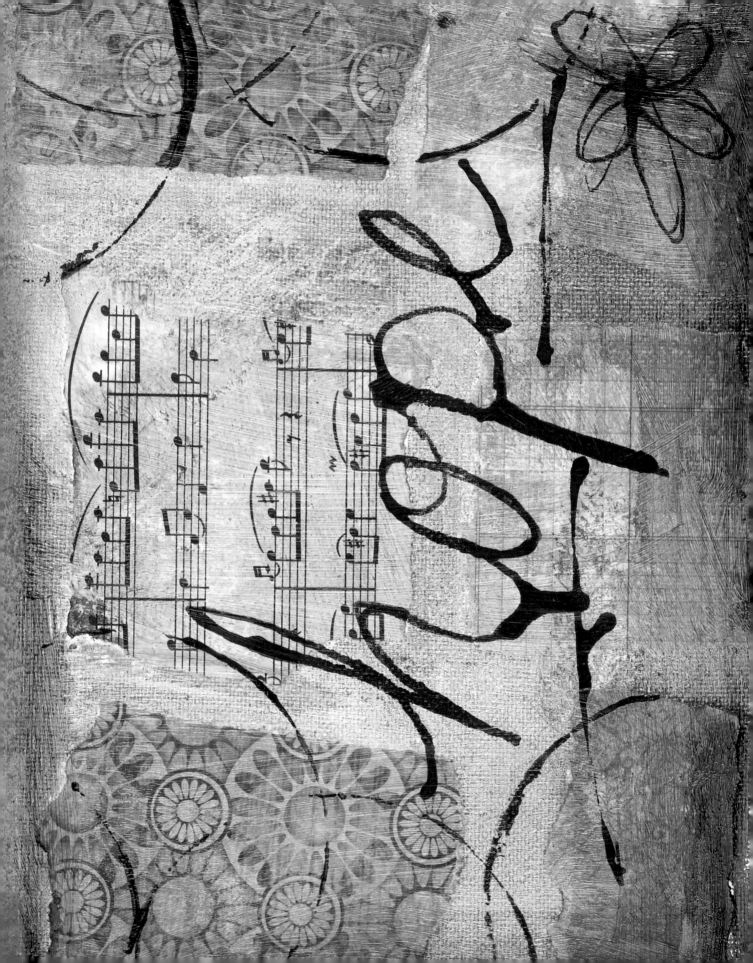

contents

introduction

A few years ago, when I discovered mixed-media art, I found myself in awe of the incredible artwork I was seeing. As I began my own artful journey, I gobbled up article after article and book after book, learning as much as I could. I loved the artwork I was creating, but something was missing: I didn't feel like it was truly mine. I was merely making pieces based on projects in books and magazines. I was great at following step-by-step instructions, but my artwork was often a replica of the project shown—a copy of another artist's work. Something was missing in my work—me.

It was then that I began taking inspiration from the techniques and materials other artists were using, and I steered away from project-based instruction. I experimented and found ways to make the techniques my own, and in doing so, my creative signature began to develop. My new artistic approach led to fresh ideas, exploration and creative self-discovery.

MODUS OPERANDI (OR, HOW TO USE THIS BOOK)

You won't find rigid step-by-step projects with precise outcomes in this book. No siree. Instead, you'll be immersed in ideas, techniques and encouragement to motivate you to create your own artful concoctions that will make *you* the artist unique.

Each contributing artist in this book—fifteen in all—has a recognizable style, and I asked each of them to share a favorite technique or two along with their own stories, insights and advice about coming into your own as an artist.

Feel free to skip around, try out some techniques, make a mess, get to know the contributors, take note of ideas that pop into your head, and go for it! Think of this book as your tool kit, full of ideas and practical tips and tricks to equip you to begin discovering your signature style.

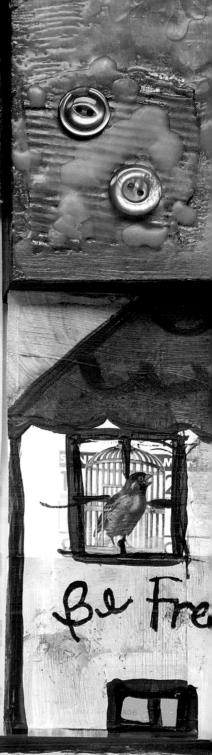

I was great
at following
step-by-step
instructions,
but my artwork
was often a
replica of the
project shown—
a copy of another
artist's work.
Something was
missing in
my work—me.

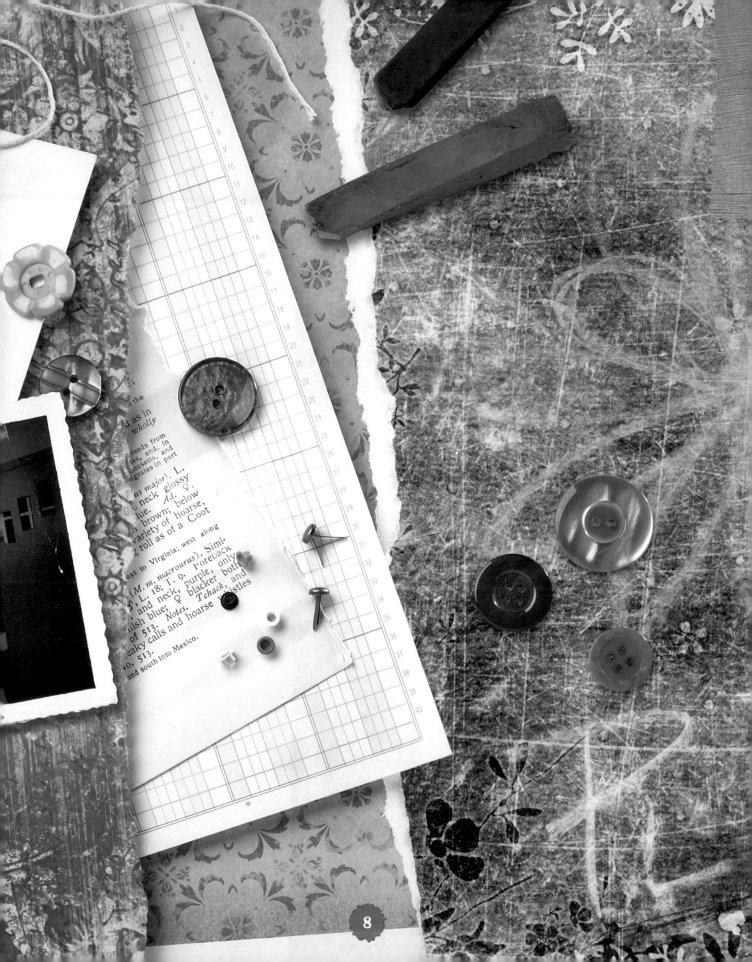

as in
choly

reeds from
ties, and in
ousetts, and
igrates in part

us major). L.
neck glossy
lue. Ad. ♀.
brown; below
variety of hoarse,
roll as of a Coot

ast to Virginia; west along

(M. m. macrourus). Simi-
s, L. 18; T. 9. Foreback
and neck, purple, only
ish blue; ♀ blacker both
of 513. Notes. Tchack, and
eaky calls and hoarse whistles
o. 513.
and south into Mexico.

1 The Artist's Toolbox

You're probably ready to dive in, but before we get into specific creative techniques, let's go over some art supplies you might want to add to your stash. Don't let this list overwhelm you; I don't intend for you to run out and buy all the items covered here. There really is no master list of must-have materials. It is entirely up to you which ones will factor into your artistic style. If you're like me, you may already know your faves. As each technique is introduced in the pages to come, you'll find a list of everything needed for that technique. So you can be selective with which techniques you try first, based on the supplies you already have or new ones you want to try.

Something to Make Your Mark With

Most of the artists in this book work in mixed media. You will see combinations of wax and embellishments, paint and collage, and pencil sketches turned into image transfers and then painted. Get creative when choosing mediums and try different techniques together to find your unique style. Here are some of the mediums that appear in the book.

ACRYLIC PAINTS

Acrylic paints are versatile and fast-drying. While still wet, acrylics clean up easily with soap and water; once dry, they are permanent. They can be used straight out of the tube or mixed with a medium or water to change their viscosity or consistency. Adding gel medium thickens paint; glazing medium thins it. Water will thin acrylics as well, but adding too much will break down the pigment-binder bond.

Some acrylics are thick with a high viscosity, like honey; others are thin with a low, almost watery, viscosity. They can be transparent, translucent or opaque. I prefer thin, transparent paints because I like to work quickly with drippy paint. I use thicker paint when adding texture to my paintings. I go back and forth between them as I work, depending on the results I want.

The look of the paint when dry will depend on how much it is diluted with water or modified with gels, pastes or other mediums. It may resemble a watercolor or oil painting, or have its own unique characteristics that you may not experience with other mediums. Try several brands and types until you find the acrylic paint that is just right for you.

WATERCOLORS

Watercolors can be purchased in liquid form (tubes) or in pan form, which is basically dried cakes of color on a plastic palette that you activate with a wet brush. Watercolors are usually used on paper and can achieve a very subtle look. I love that they are portable and can be used just about anywhere. I've been known to borrow my children's watercolor sets to add some subtle color to my art journals. Another benefit of watercolors is their easy cleanup and minimal mess.

WATERCOLOR/WATER-SOLUBLE CRAYONS

Watercolor crayons are made from semisoft watercolor. Once applied to the surface, the colors can be easily blended with a wet brush. They are a fun medium that is great for art journaling, watercolor painting and adding color washes and bursts to mixed-media pieces.

PASTELS

Soft pastels or pastel chalks are made from pure pigment and contain just enough binder to hold the stick together and to transfer the color onto a surface. Their consistency and feel varies from hard and dry to soft and creamy. Harder pastels work

great for laying a bottom layer, but their chalkier consistency makes them not stick as well when applied over other layers. Softer pastels will adhere to almost any surface. Pastel chalks come in fat half sticks and typically thinner full sticks, plus square sticks, which are ideal for fine detail and lines.

Oil pastels can be blended and thinned with brushes that are wet with mineral spirits or thinners. They have the same variation in textures as soft pastels. Some are a little smoother than others, some are tacky and some are more stiff.

ARTIST PENS AND MARKERS

Try various pens and markers on several surfaces to see what works best for your creative needs. Consider whether they are permanent, how quickly they dry and whether they will smudge if they get wet.

Some favorites of the contributing artists are Faber-Castell pens, PITT artist pens, Rapidograph, Sakura Gelly Roll, Pigma Micron pens, Prismacolor markers and a crowd favorite— regular Sharpie markers. I've found that Sharpie Poster Paint markers will write on just about anything, and the white ones dry completely opaque. They are perfect for art journaling and for writing or drawing on top of mixed-media paintings.

ARTIST'S INKS

Ideal for calligraphy, drawing, writing, painting and stamping, artist's inks come in many colors and can be used with quill pens or brushes. Although artist's inks are often used for delicate lines and intricate writing, I love to express my messy style by using an eye dropper or brush handle dipped in ink to add messy hand lettering to my artwork.

INK PADS

Ink pads are most commonly used with rubber stamps, but don't let that stop you from experimenting. Ink pads are a great way to add background color to paper, and they work well when stamped directly through a stencil. I love to use them to distress the edges of both ephemera and new papers to make them look old or worn. The most common types of ink pads are dye and pigment based. Dye inks are thinner than pigment inks, and they will dry faster as a result.

POLYMER CLAY

You can use polymer clay to create intricate sculptures, beads and jewelry pieces, or even make embellishments to be used in mixed-media art. It comes in a variety of colors and brands. It is soft and easy to work with and will stay pliable until it is baked. It bakes hard and can then be left as is or painted.

what's on *your* palette?

Choose a color palette that is meaningful to you. Your personal palette will evolve as your signature style does. I know artists who always add a small splash of red to their paintings. I know another who generally works in earth tones and yet another whose paintings are always bold and vibrant, with large areas of primary colors throughout. In addition to their individual styles of painting, their color palettes are unique to them. Their palettes set them apart and help to define their overall artistic style.

When thinking about your palette, consider what you already know and love. Take complete creative liberty and play with color. Try different colors together and see what speaks to you and your creativity. You can choose a small number of colors to work with or as many as you like. You make the rules!

It's your palette, so discover your personal color preferences in a way that best suits you and your learning style. Here are some suggestions to get you started:

- **Visit your local garden center and look at the flowers.** Which ones make you smile and make you want to get closer? Their shapes and unique characteristics may catch your eye, but it's likely their colors are part of the attraction, too. Make a mental note and write it down or—if you're like me and always have a digital camera on hand—snap a picture of the flowers you love.

- **Head for the paint chips in your nearest home improvement store.** Which colors do you naturally reach for and gravitate toward? Grab some and take them home with you. Pin them on your inspiration board or stick one in this book as a bookmark. Just put them somewhere safe so you can come back to them later.

- **Go on an at-home scavenger hunt.** Head for your refrigerator, pantry, clothes closet, linen closet … just look around. What colors do you see repeating? Those are probably your go-to colors.

- **Visualize.** Close your eyes and visualize. Imagine you are at your very favorite place at the absolute best time. Look around; what do you see? What colors are you surrounded by? Are the rich hues of autumn where your bliss lies? Or the tranquil shades of a seaside paradise? Maybe the colors associated with a memorable event, such as Mardi Gras or Holi (fittingly, a Festival of Color celebrated by Hindus), are what you are drawn to. Take note of them.

- **Ask yourself what colors make you happy.** What colors make you feel comfort, safe, daring, alive? What colors scream YOU?

Have fun discovering your signature color palette! Use a few or all of these exercises to help you find the perfect color palette and begin to identify your signature look.

APPLICATION TOOLS

Although you can use just about anything to apply your paint and mediums to your surfaces, you'll want to choose the right tool for the job. Your fingers might not be the best tool if you're looking to achieve a rigid line, for example. Different tools and applicators will yield differing results. You may find your style evolves based on the tools you feel drawn to.

PAINTBRUSHES

When shopping, you may see that some brushes are labeled as being for a certain medium. But you can use any type you like, regardless of its designation, as long as you keep any brushes you use for oil painting separate from the rest. Those you use for watercolor can also be used for acrylics and vice versa. As long as you clean them after each use, you can use them across mediums.

As for shape and size, you'll find a huge variety. Try different ones to discover your favorites. I have a whole bucket full of brushes, and I tend to go back to the same few. I also like to keep some old ones around for special jobs, such as applying adhesives or scrubbing stains.

SPONGE BRUSHES

Sometimes called sponge tip applicators, sponge brushes work well for applying gel medium or other adhesives to your artwork. They also work wonderfully for applying a large amount of a medium quickly—like gesso to a large canvas—or putting on a base layer of paint

PALETTE KNIVES

Palette knives are often used by oil painters to apply paint, but they're also useful for mixed-media artists who like to drag paint across a surface or smooth out bumps when adding collage elements to a piece. Small ones are good for applying adhesive for small collage elements or other embellishments. Old credit cards can also accomplish much of what palette knives do.

STAMPS AND STENCILS

You can use stamps with ink, paints or other mediums to quickly add images, numbers, letters or other text and shapes to your artwork. Any craft store or scrapbooking store is generally stocked with stamps that have just about any image you can imagine, but if you are looking to put your own unique mark on your artwork, consider carving your own stamps. Stamps can be carved from linoleum or rubber blocks with carving tools. There are stamp-making kits available that contain all the necessary tools to carve your own design.

Stencils are another simple way to add creative elements to your art. Ready-made stencils are widely available, or if you can't find what you're looking for, they are fairly simple to make. Stencil-making kits come with thin, flexible (yet durable) plastic that can be drawn on, and then cut or burned for your desired design. Stencils can be used with all sorts of mediums, including acrylic paints, inks and spray paint.

Texture Makers

Experimenting with texture can help you identify unique approaches that might become part of your signature style. Many mediums and tools are available to help you create texture in your artwork. Here are a few of them.

ENCAUSTICS AND WAX

Encaustics is painting with encaustic medium, which is made of beeswax, damar resin and pigments. The melted wax is applied to a surface and then reheated to fuse it. Encaustics can be polished to a high gloss, and it can also be drawn into, scraped, textured, embellished, collaged into and so on. Because it cools immediately, there is no lengthy drying time, and layer upon layer can be added and worked in very quickly.

Similarly, regular beeswax can be melted and used in collage and to add texture to mixed-media artwork.

GESSO

Typically used as a primer to prepare canvas and other surfaces for painting, gesso can also be used to create texture. You can stipple it onto a surface with a crumpled plastic bag or bubble wrap. Or you can apply a thick coat of gesso and scrape, scribble or stamp into it. When dry, the texture will remain when you paint over it. Alternatively, if you have a surface that is too rough, you can add several layers of gesso to help smooth it out enough to paint.

CRACKLE MEDIUM/ PASTE/PAINT

Several types of mediums are available for creating a crackled (or cracked) appearance in your artwork. Three of them are shown in this book: crackle paste (Golden), crackle paint (Ranger Distress) and crackle medium (Plaid FolkArt). Their application and effects vary, as you will see in the technique demonstrations. If you like crackle texture, give these a try and see which works best for you.

SPACKLE AND MOLDING PASTE

Yep, I'm talking about the kind of spackle found in your local hardware store. Molding paste is similar to spackle in some ways, and either can be used in your artwork for dramatic texture. You can use a palette knife to spread it on your surface and create all kinds of texture can be created by stamping, scraping or drawing into it; or use a big palette knife or other large, flat tool to press into it and lift to create peaks. Texture can also be added after the spackle or molding paste is dry by carving into it with knives or other tools.

TEXTURE TOOLS

Texture tools can be used to press into or scratch the surface of your artwork to create texture. You can get a wide range of effects with these tools, many of which can be found around the house:

- chopsticks
- cardboard coffee cup sleeve
- paper doily
- bubble wrap
- old credit/gift cards
- fork
- sequin waste (aka punchinella)
- lace
- paper towels
- string
- twine
- lids
- sticks
- real or artificial leaves (used to make impressions)
- bottom of a shoe
- spring
- top of a salt shaker
- garden tools

Can you think of other everyday items you could use to create texture in your artwork?

Something to Make Your Mark On

Three basic art surfaces are used by fine artists: paper, board and canvas. When you factor in mixed-media artists, however, the possibilities for surfaces upon which to create on increase exponentially. These artists create masterpieces with everything from metal to doll parts to the sides of brick buildings.

Think about your approach to creativity and the kind of artwork you are drawn to. If you would like your artwork to be light and delicate, perhaps creating on paper or stretched canvas will suit you. If you are thinking of building a dimensional piece or adding heavy embellishments to your artwork, you might want to consider a sturdier substrate.

Another factor to think about is how well the surface will accept wet mediums. There are different papers suited for watercolor, for example, or designed to withstand mixed-media painting. If you are considering using a great deal of wet medium on canvas or wood, you will need to ensure that you've prepped your surface with gesso or primer, or take into account that color absorption or bleeding may occur.

There are countless substrates or surfaces you could create on, and if you've gone green and want to continue that environmental effort in your art, you can even use found objects to begin your artistic process. Here are some of your options.

WOOD

Wood, also referred to as "board," comes in a variety of types—chip board, plywood, fiberboard, Masonite and MDF—and is readily available at art supply stores and hardware stores, or even in scraps left over from home remodeling projects and old, broken furniture.

Wood is one of my favorite surfaces to work with. I am rather aggressive with my work, so I need a surface that won't stretch, bend or fall apart when I add layer upon layer of paper, paint, glue, wax or embellishments. Wood will withstand the abuse I like to give my artwork during the process of creating it. I can hit it with a hammer to add character. I can carve into it with a knife. I can nail embellishments onto it. The possibilities are endless. Wood is perfect for the physically expressive artist.

CANVAS BOARDS

Canvas boards are another favorite of mine. They have the surface characteristics of canvas,

but contain a core made of heavy cardboard. These boards are ideal for canvas-loving explorers who like to embellish or add collaged layers to their artwork. Canvas boards are also extremely affordable, often come in packs of three and can be found just about anywhere inexpensive craft paints are sold.

STRETCHED CANVAS

Ready-made stretched canvases come in a wide variety of shapes, sizes and depths, and are made from cotton duck or linen. Cotton duck is much more affordable than linen and is readily available at craft stores and art supply stores. Most prestretched canvases come prepped with gesso and ready for painting. Canvas requires a gentle approach and is ideal for detail work or gradually layered paint.

PAPER

Whether you're sketching, doodling, journaling, painting with watercolors or making mixed-media pieces, there is a perfect paper for the job. Paper comes in many varieties: watercolor paper in numerous weights and presses (textures), acrylic paper, sketchbook paper, newsprint, scrapbook paper, graph paper and even spiral-bound journals made specifically for mixed-media artwork and art journaling. Handmade journals are available in some stores and on websites such as Etsy.com, or you can choose your favorite papers and make your own.

CARDBOARD

Cardboard is an inexpensive (sometimes free) alternative to canvas board and is a great surface to let loose and play on. It's tougher than paper, so it will hold up to rougher applications of mediums and collaging.

Other Creative Paraphernalia

Introducing unique collage elements, images and embellishments is another way to put more of your personality into your artwork. Perhaps you have a love of photography; consider collaging some of your favorite photos into your art.

Maybe you've collected random oddities like screws, washers, hinges or knobs in a junk drawer. How could you incorporate some of those items into your next piece?

Creative inspiration can come from completely unexpected places. You never know when you might find the perfect item to add to your stash of creative paraphernalia. Consider the artistic potential of these items and others:

- assorted papers
- ephemera (such as pages from old books)
- buttons
- stitches
- lace
- tape
- wire
- brads
- eyelets
- photos
- postage stamps
- beads
- fabric scraps

- tickets (theater or even parking tickets)
- doll parts
- skeleton keys
- typewriter keys
- vintage photo slides
- hinges
- nuts and bolts
- cutouts and punches
- game pieces
- ribbon
- anything with holes drilled in it
- coffee cup sleeves
- phone book pages
- newspaper
- spools
- clothespins

ADHESIVES AND FASTENERS

When you think of adhesives and fasteners, what comes to mind? Glue? Staples? Duct tape? There are countless ways to attach and affix items to your artwork, and it can be daunting to try to figure out which method is best for your needs.

You'll want to consider what you're sticking and where you're sticking it when choosing your adhesive. If you are working with collage pieces, you'll want to avoid an adhesive with a high water content, which may cause paper to buckle and warp. Gel medium is good for a lightweight collage and serves as a sealant as well, but it can be messy. If you're looking for a quick, simple and virtually mess-free option, double-sided tape might be your best bet. Repositional adhesives are perfect when you're not ready to commit to exactly where you want something to be.

On the other hand, if you're looking to fasten something to your artwork that adds to the visual aesthetic, consider trying brads, wire, eyelets or even staples.

If you are adding lightweight embellishments—bottle tops, game pieces or rusty nails, for example—consider a heavy gel medium. For heavy or bulky adornments, you'll want to use a heavy-duty adhesive such as E-6000 glue or Gorilla Glue.

Here are some of the attachment options you could try:

- gel medium (in different weights)
- staples
- eyelets
- tape
- twine

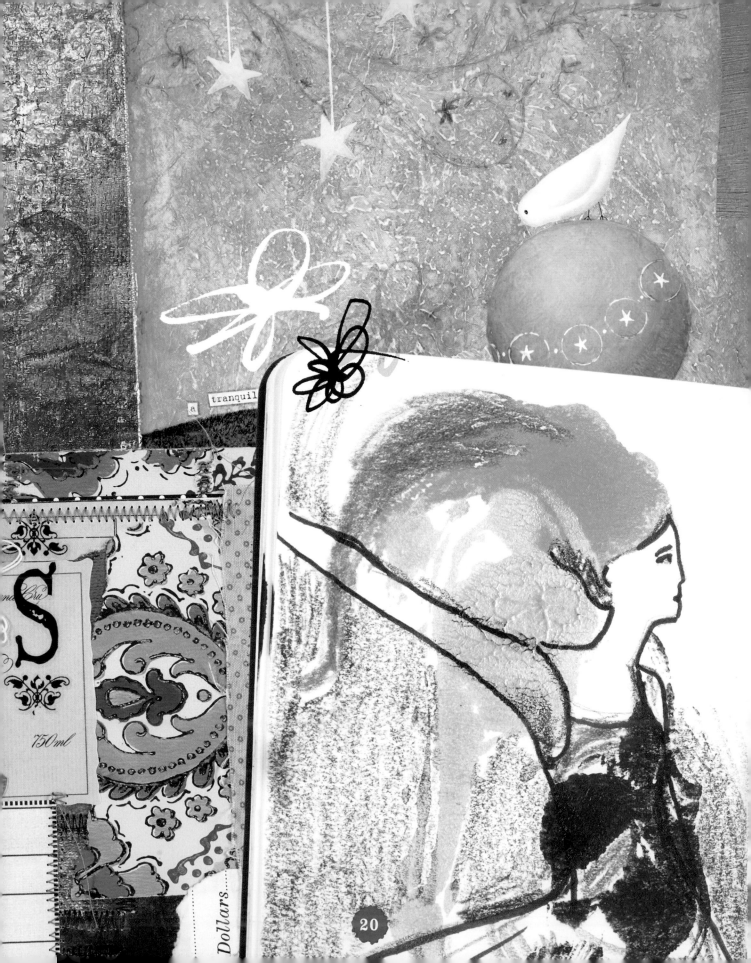

a tranquil

S

750ml

Dollars

2 Discovering Technique

Step inside the creative minds of a diverse group of artists as they share their stories—what their motivations are, where they find inspiration, and how their styles have evolved—along with the favorite techniques they use in their own signature ways to create unique art. Throughout, you'll find my step-by-step demonstrations of those techniques, which I've incorporated into my own unique pieces of art. As you will see, my take on these techniques results in a different look than that of the contributing artists. Your results will be your own too. Feel free to alter these techniques to make them more *you* and combine them for a variety of outcomes. I hope the stories, artwork and techniques you see here inspire you to dig a little deeper, release your inhibitions and step into your power as the artist you are.

pure Muse

Leah Piken Kolidas

You know how when you're little, there are bits of your personality that are with you right from the beginning? These parts of you make up your essence, what makes you uniquely *you*, and this way of being in the world stays with you throughout your life.

I believe that's where the main part of my style comes from: that essential part of me. And I believe that we all have access to our unique way of seeing the world and creating, if we can only stop resisting and let it flow. Part of my style evolution has come from simply allowing more

of myself to show up in my work. It can be risky to put yourself out there sometimes, so I think the more I've trusted myself, the more my style has evolved to become something that's more me.

In my artwork, I work intuitively, creating mixed-media pieces that come together like a visual puzzle. I enjoy working in layers because I think it mirrors the way my mind works—all the memories, stories, dreams, thoughts, experiences and connections that come together to make up who I am. I think the stories I tell through my art are autobiographical in some ways, but because they're told in imagery, symbols and metaphor, they're also universal stories that others can relate to.

At first, I wasn't sure I had a signature style. But then other people mentioned that they could recognize my art from a mile away. It seems to happen to a lot of artists: They don't think they have a style, but if they ask others, they will be told that their style is very recognizable. When I

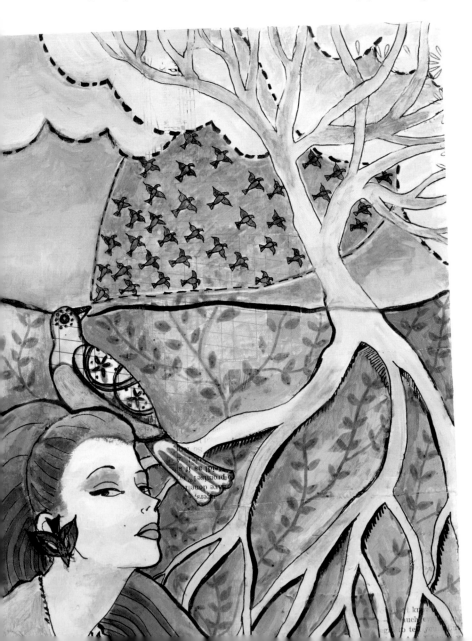

A Little Bird Told Me
Leah Piken Kolidas
Mixed media on wood
12" x 9" (30cm x 23cm)

took a step back, I could see that my style has come out of my own unique way of seeing the world and the way I naturally create.

Some of my style comes from the colors and symbols I'm drawn to. I work in a lot of blues, for example. But I also have a way of working with materials, a way of drawing and collaging, that is uniquely me. I didn't have to think about developing it, but it's interesting to look back and recognize it.

Beyond what I see as coming through naturally, I think my style has evolved and slowly developed as I've become more comfortable with the mediums I work with, as I try new things, as I work with different themes and as my interests shift. My style has slowly evolved as I've evolved as a person. Since I'm always changing, it's in constant evolution, but it's always felt like a slow, smooth transition.

Where do you find inspiration?

Everywhere! Really, I think inspiration can be found everywhere, if our eyes are open and looking for it. I find inspiration on walks in the woods, in the color combinations I see in junk mail, in reflections in puddles, in blogs I read, in my dreams and in whatever is going on for me internally.

One of the most important things I've learned about my own creativity is that I don't need to wait for inspiration to hit before I begin working on my art. If I simply show up and begin creating, the inspiration will come.

Star Shepherd
Leah Piken Kolidas
Ink and watercolor pencil on paper
11" x 7" (28cm x 18cm)

Draw With Your Eyes Closed

MATERIALS

Sheet of paper

Pencil or pen

Music (between ten and fifteen seconds is all you'll need)

Optional: colored pencils or markers

When Leah Piken Kolidas has trouble getting started with her art, this is one of the intuitive warm-ups she does to get her creative juices flowing. There are a few ways you can approach this form of intuitive doodling, from taking a very relaxed approach—classical music and deep breaths—to selecting a song that you can rock out to as you draw. Whichever direction you take, have fun and don't worry about the end result—just draw.

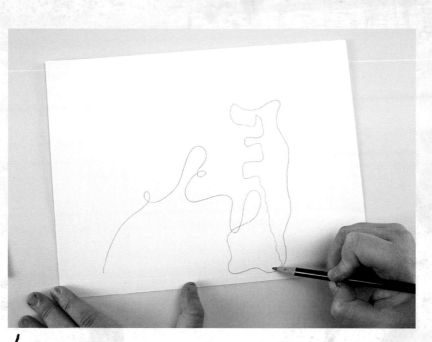

1 Grab a pencil or pen and a sheet of paper, and get your music ready to play. Start the music, close your eyes and put pencil to paper, letting the pencil take you wherever it wants to go. Stop the music after about ten or fifteen seconds and take a peek.

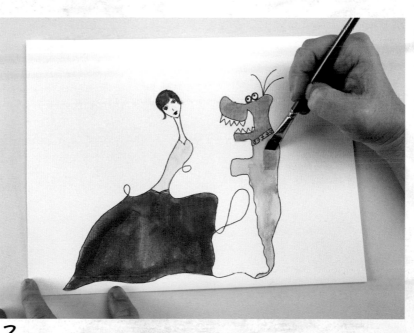

2 Take a moment to look at what you've scribbled. Do you see anything there? Maybe a face? A monster? A house? A fish? Or maybe a tree? Whatever you see there, take a moment to bring it out. You may color it in with colored pencils or markers, or just make it clearer with your original pen or pencil.

Develop an Ink Blot

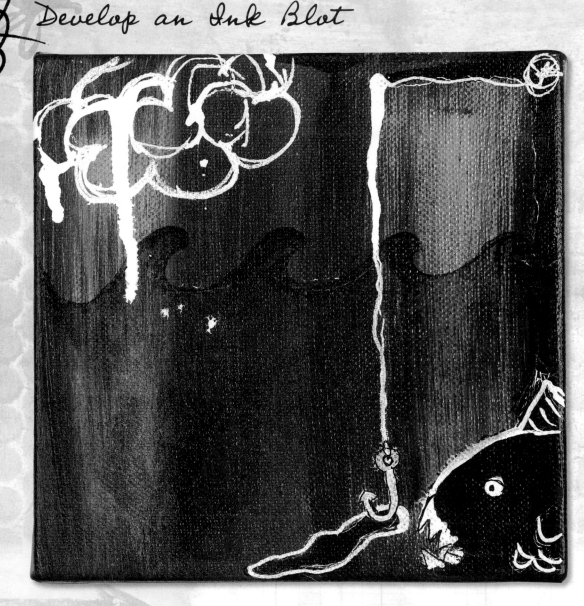

MATERIALS

Two substrates
that you can press ink between
(small canvases,
sketchbook pages, etc.)

India ink

Acrylic paint, markers or pens

Ink blots are an easy, playful, low-pressure way to get started creating from your intuitive side. When I flew to Cincinnati for this book's photo shoot, a bottle of India ink leaked in my luggage. When I saw that it had gotten on two of my prepainted canvases, I was a little disappointed. I thought they were ruined, until I remembered that ink blots were one of the intuitive techniques we would be photographing. It was perfect!

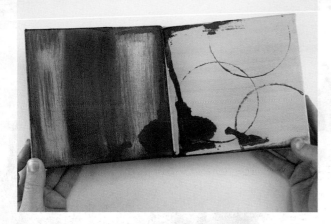

1 Though my inky beginning on these two canvases was completely accidental, creating your own ink blot is super simple: Just squirt some ink or paint onto a page of your sketchbook. Then close it, press lightly and open it up to reveal your ink blot. Once it's dry, take a look and see if any images pop out at you.

2 As I looked at my ink blots, the big blob of ink on the bottom right of one reminded me of a fish mouth. As soon as that vision popped into my head, the whole scene began to take shape in my mind—the hungry fish, the poor worm and the fishing pole from above. I wanted to keep it simple, so I grabbed an opaque white gel pen (Sakura Gelly Roll) to outline and detail the fish and the worm, and then added the fishing line and hook.

Ink blots are a great way to play creatively and use your imagination. Perhaps something will appear in your ink blot that relates to something in your life. Or it might be pure silliness, like mine here. Either way, let go and enjoy the process of developing what you see, as far as you want to take it.

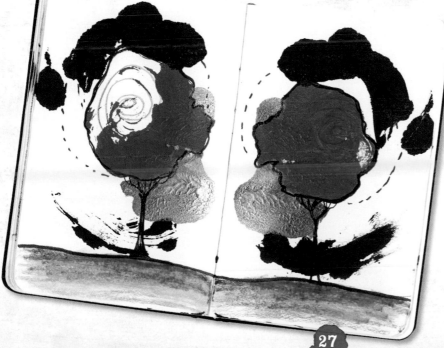

A developed ink blot from Leah Piken Kolidas, who has a 5.5" x 3.5" (14cm x 9cm) journal full of them. For more inkblot pages from Leah's journal, turn the page.

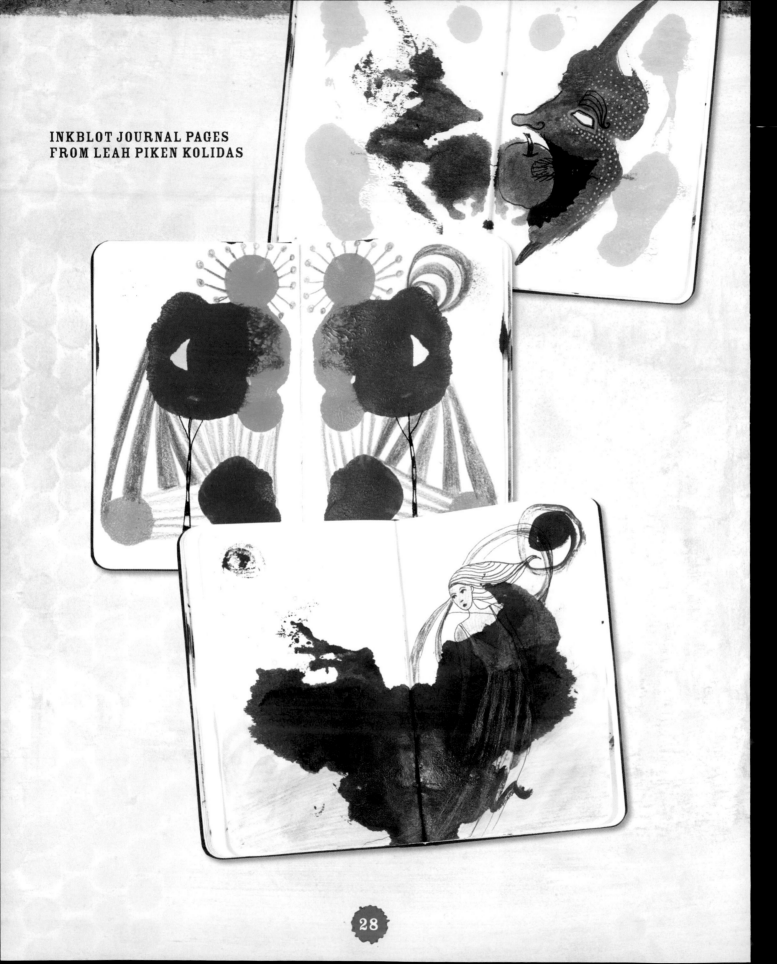

INKBLOT JOURNAL PAGES
FROM LEAH PIKEN KOLIDAS

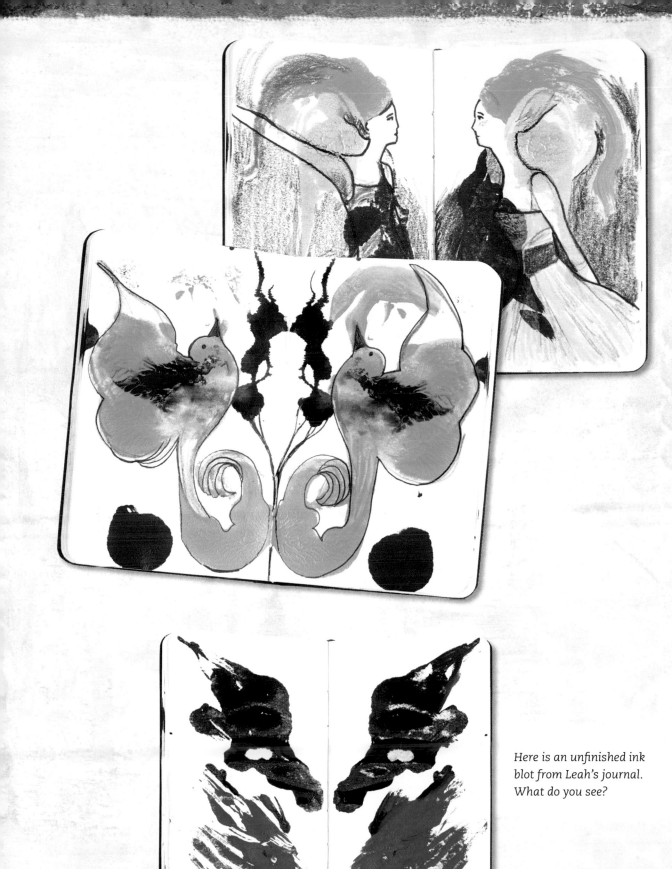

Here is an unfinished ink blot from Leah's journal. What do you see?

master word list

Find words that are meaningful to you. Words that inspire, get you fired up, or simply make you smile—words you don't want to forget. Gather at least twenty-five and as many as a hundred or more.

Your words may come from anywhere! Here are some suggestions as you set out on your word search:

- Flip through magazines and cut out text that stands out to you. Don't over-analyze why; it doesn't matter. It could be the color, font, the actual word itself—anything. Just find words you like and cut them out.

- Go to a bookstore or library (or a related website). Go to your favorite section. Glance over the titles and jot down words that stand out to you.

- Look over the random word list on the next page. Circle words that appeal to you, that describe your ideal artistic self, that stir emotion in you or that you just love, even if you don't know why.

- Think about your favorite movie and your favorite scenes from it. What words describe that scene? Now grab a thesaurus (or find one online) and look up words that are synonymous with your description of your favorite scenes. Write down the ones you like.

- What are your favorite song lyrics?

- What is your favorite poem?

- Do you have a favorite quote?

- Are there words you've always found fascinating?

- Where is your favorite place in the whole world? Describe it. Do the thesaurus routine if you need to. What words describe it?

- Where else do you find words you love?

How's your list coming along? Keep it in a safe place. Add or remove words as necessary.

Use this word list any way that suits you. Refer to it as necessary for a little burst of inspiration when you're creating. I like to circle words that jump out at me and incorporate them in my artwork. Whether you enjoy art journaling, painting or collage, there are many ways you can incorporate text into your artwork. Alternatively, you might just use your favorite words as inspiration for the theme of a piece or theme of a whole series of pieces. Let your imagination run wild.

blissful
tough
desirable
valiant
modest
ingenious
solid
courageous
profound
adaptable
worthy
colorful
joyful
cute
delectable
dependable
remarkable
confident
funny
ready
magnetic
enlightened
authoritative
righteous
luminous
exact
ecstatic
lovely
entertaining
decent
beautiful
sexy
assured
progress
merit
sensual

sublime
sympathetic
compatible
discrete
efficient
humorous
engaging
serene
happy
grateful
determined
sincere
authentic
content
focused
extraordinary
delightful
imaginative
success
heroic
cheerful
inventive
unique
gleeful
sparkling
soulful
spontaneous
fascinating
rock star
brilliant
constant
natural
keen
merry
eloquent
comfortable
relax
loyal
stable
alive
charming
truth
enough
gorgeous
brave
innocent
enchanted
noble
responsive
precious

satisfied
deep
cozy
just be
creative
gentle
harmonious
kissable
benevolent
lucid
nice
fun
bold
rich
tender
fantastic
jolly
whimsical
immaculate
bright
vigorous
wonderful
alluring
reflective
elated
impressive
playful
superb
devoted
pleasant
warm
dedicated
amazing
calming
desire
confidence
subtle
personable
peaceful
stylish
hope
excellent
chic
intuitive
courteous
disarming
caring
fine
logical
tranquil

virtuous
attentive
provident
thoughtful
cerebral
jubilant
affectionate
forgiving
mindful
understanding
fruitful
winsome
sociable
elegant
fertile
great
free
daring
deserving
polished
real
admirable
blessed
breeze
godly
powerful
convulsive
fabulous
gracious
affirmative
direct
wise
robust
consistent
independent
compassionate
artistic
genuine

smooth
spry
complex
accomplished
astute
rejoicing
philosophical
established
grand
important
resolute
radiant
candid
deliberate
flexible
reliable
terrific
sharp
democratic
impressive
sweet
charitable
productive
saintly
waves
wondrous
stupendous
willing
awesome
sincere
splendid
sophisticated
prolific
worldly
energetic
generous
sunny
fashionable
mature
light
reasonable
priceless
suave
forthright
hilarious
respectful
comely
spiritual
appreciative
precious

steady
spirited
self-reliant
scrumptious
nourishing
thankful
positive
airy
valiant
romantic
adorable
poetic
attractive
chilly
sentimental
ambitious
visionary
lively
prudent
vivacious
vicious
tender
dignified
agreeable
heavenly
encouraging
rosy
gallant
versatile
purposeful
enthusiastic
passionate
captivating
strong
sprite
active
distinctive
responsible
special
excellent
fabulous
incredible
remarkable
smart
spectacular
splendid
stellar
super

ultimate
unbelievable
outstanding
color
messy
fierce
wicked
friend
warm
dazzling
treasure
treat
abundant
random
delicate
debonair
divine
sassy
deluxe
flourishing
juicy
invigorating
hot
inspired
home
reach
squeal
nature
nurture
clouds
autumn
sandy
steady
bold
empower
raw
emotion
feel

Lynne Hoppe

When I started keeping an art journal three years ago, it was the first time that I'd drawn in almost thirty years. I remember taking a drawing class when I was twelve years old and failing miserably at it, and from then on, it seemed to be unspoken knowledge that I had no talent for art.

As the years went by, I made things, lots of things, but I didn't draw or paint again until I was fifty-one. At that time, a couple of my friends decided to start art journaling, and I joined in. I had a blank journal full of watercolor paper and a bunch of Caran d'Ache Neocolor II crayons, and I loved filling up those pages! Now I draw every day. I'm in love with drawing and painting, and I'm in love with color.

I've drawn mostly with my nondominant hand (my left) since I started journaling. Not only do I like the childlike quality of drawings done with my left hand, I also like the fact that it helps keep my inner critic silent; after all, I can always say, "But I drew it with my left hand!" Once I've drawn an image, I paint it in a one-thing-leads-to-another way; I paint the first thing that calls to me and go from there.

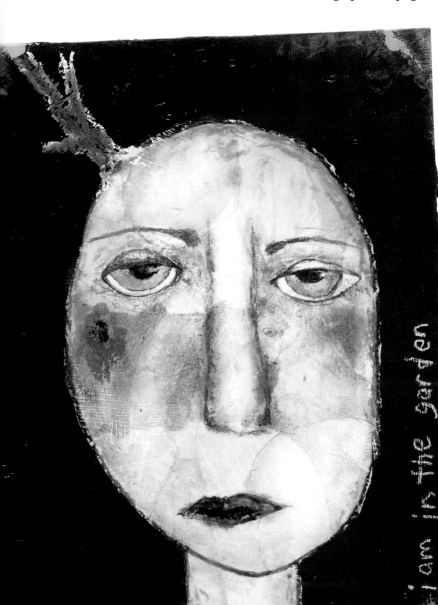

When I started keeping an art journal three years ago, it was the first time that I'd drawn in almost thirty years.

I Am in the Garden

Lynne Hoppe

Colored pencils, oil pastels, watercolor and acrylic on 300-lb. (640gsm) Arches watercolor paper

7" x 5" (18cm x 13cm)

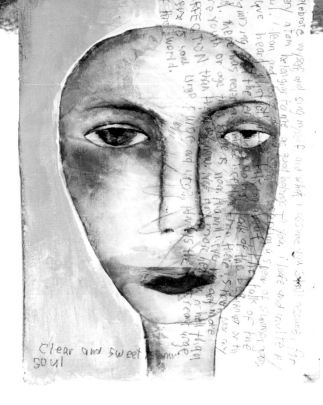

**Clear and Sweet
Is My Soul**

Lynne Hoppe

*Colored pencils, oil
pastels, watercolor
and acrylic on 300-lb.
(640gsm) Arches
watercolor paper*

7" x 5" (18cm x 13cm)

Mediums I love

Watercolors *were my first
love, and by far my favorites
are Caran d'Ache Neocolor
II crayons and LuminArte's
Twinkling H2Os. You can
paint with these on anything
as long as you put a layer of
matte gel medium down first.
They're highly pigmented,
easy to work with, afford-
able—and they come in lots
of colors. I dip the crayons in
water and paint directly on
the page with them or use
a brush to pick up paint
from them.*

*These days I use **oil pastels**
and **colored pencils** as much
as my trusty watercolors.
You can cover larger areas
with oil pastels and work in
smaller spaces with colored
pencils. You can use oil pastels
to shade colored pencils and
vice versa; I use both paper
blending stumps (tortillions)
and blending pencils to blend
the two. As long as you don't
have a thick layer of either,
both remain workable.*

***Payne's Gray** is great for
shading, but it does so much
more. It's more subtle than
black, yet it can appear as
black. It has a sort of chame-
leon-like ability to work in
the most appropriate way
in each situation.*

I'm inspired by so many things, but most often by thoughts or images from my inner world. I often feel compelled to draw what I'm feeling or seeing with my inner eye—ideas come to me from dreams and feelings about my interactions in the everyday world. Painting, for me, is a form of self-expression—a way to reveal what my conscious mind cannot bring forward in a linear, logical way. If I feel no inner inspiration, I look through art books (Chagall, Matisse and Hundertwasser are some of my favorites) or magazines. I especially like to look at outsider art and the outsider art magazine *Raw Vision*. Usually just a few minutes of leafing through these will have me champing at the bit to paint. If I have absolutely no desire to draw or paint, and looking at books doesn't help, I trust that it's time to take a break. I do something else until the energy returns, usually within a couple of days.

Lately my process has become more purposeful; I think about which medium is best suited for the next step, rather than a vague "What do I want to use next?" The core of what I do is still intuitive, though. I've found that art, like life, flows more easily if I trust my intuition and leave off with too much thinking. I've found that no matter what I'm doing, the next step will appear—as long as I'm paying attention.

Draw With Your Nondominant Hand

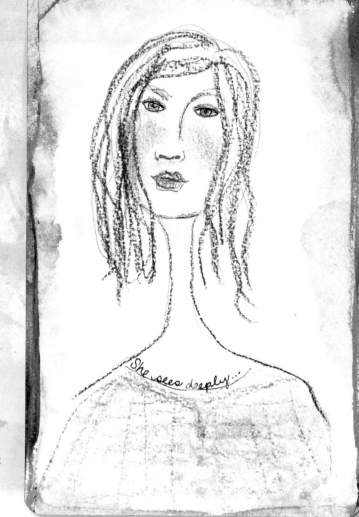

She sees deeply...

MATERIALS

Any medium(s) and surface you want

When I first read Lynne Hoppe's approach to drawing with her nondominant hand—and further, the way she approaches her artwork—I was a little intimidated. I think it's my inner perfectionist worrying that purposefully working with my off hand is inherently wrong. Now that I've tried it, however, I'm hooked. I love how freeing it is and how it requires me to let go of the need to be proper. Here is one of my examples that I did in my watercolor Moleskine art journal with Lynne's written instruction. I was so pleased with the sketch that I added some color with water-soluble crayons and finished it up with a black marker.

1 The first (and most important!) step is to gather materials that you love. They must sing to you; they must make you smile! They're your partners in this adventure, and you've got to have a good relationship with them.

2 Now decide what you want to draw—anything from the glass on the table beside you to something that you imagine. It should be something that speaks to you, something that you like. This generates interest and enthusiasm that can help you through rough spots later on. If I can't think of anything to draw, I usually draw something simple that I love—winged hearts are an old standby for me. The idea is just to get started; things will usually flow from there.

3 With your nondominant hand, start drawing your subject wherever it feels right to start. For a face, I often start with the outline of the head. Feel free to erase, but don't be too particular. Think about how what you're drawing feels more than how it looks.

4 Continue drawing in a one-thing-leads-to-another way. For a face, I usually "see" the neck after I draw the outline of the head, so I draw that next. It may take a few tries until I like what I've drawn. Then I might have an idea about what kind of nose would look best, then the eyes and so on.

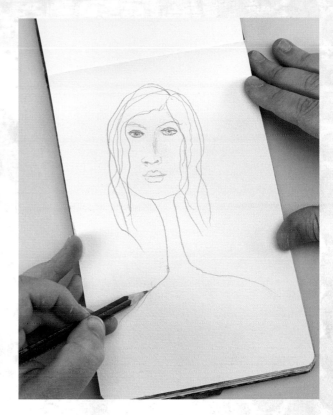

5 Look for any small changes you might want to make. If all feels right, look to see what you know how to paint. For a face, this might be the general skin tone, so I paint that, and then I move on to the next part I think I can paint. Keep going in this manner until everything has been painted. If I'm working on a page that has lots of images, I jump all over the place. My basic plan is to always paint the next thing that calls to me, the next thing I know how to paint.

6 If you find that you don't like what you've got, look at the painting with a soft gaze and see if anything jumps out. Consider radical measures if subtle changes don't improve your picture. I've often used acrylic paint or paper to cover up part or all of what I've done, used a china marker to heavily outline areas, or covered a piece with a fresh layer of matte gel medium, which lets me add to it without messing up what I've already done. Don't fret that you've just covered up what you spent hours creating. The energy of what you've done will come through.

Shari Beaubien

Creativity has always been a part of my life. You might say it's my very essence. However, my family never placed value on such impractical endeavors. The goal outlined for me necessitated finding a "real" job—you know, the kind of job that comes complete with a corporation and a salary to back it up.

I tried. For years, I tried. At first, I relegated my creative bursts to hobbies that I could pursue for a few rare hours in the evenings and on weekends. Soon enough, though, it became apparent that my inner life was shriveling and dying. Next, I attempted a string of slightly more imaginative ventures, such as teaching aerobics, styling hair

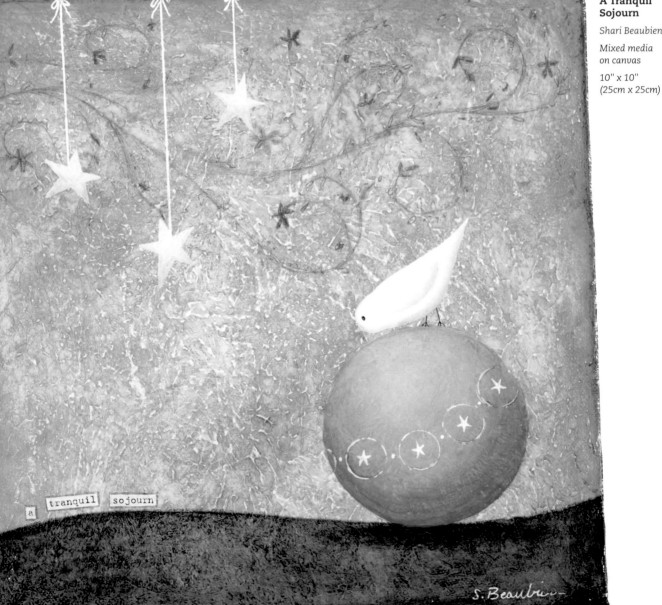

A Tranquil Sojourn

Shari Beaubien

Mixed media on canvas

*10" x 10"
(25cm x 25cm)*

and running a calligraphy business. All of these jobs felt closer to my bliss, but still slightly off the mark.

Then one glorious, sun-drenched morning, I decided to let go of all the expectations and begin to live my life for me—no one else, just me. I chose to pursue my artwork full time without fear or reservation. And you know what? A funny thing happened. I discovered that when you allow yourself to become your truest and most authentic self, then the universe rallies behind you. It was that simple. Success has since streamed in, appearing in myriad shapes and forms, sometimes looking nothing like I had ever considered. But it's there. And I am happy. For the first time in my life, I am supremely, down-to-my-core happy.

My paintings chronicle this inner journey. I never need to search any further than my own heart for the subject matter I convey. Usually an image will flood into my mind, and I do my best to record it faithfully in my sketchbook. I try not to censor or refine it. After allowing that initial rendering to sit in my

Often, it's not until I have painted several images in a series that the meaning of a particular piece reveals itself to me.

Finding Folly
Shari Beaubien
Mixed media on canvas
10" x 8"
(25cm x 20cm)

subconscious for a bit, I'll then imbue the image with rich, saturated color and paint it into being on my canvas.

Often, it's not until I have painted several images in a series that the meaning of a particular piece reveals itself to me. But it always does. I continue to be amazed by the vast

trove of knowledge that resides within each of us. It seems that we already possess all of the answers to life's toughest questions, if only we choose to listen. My work has evolved in the sense that I spend more time sitting quietly, allowing for this dialogue to happen.

Texturize a Background With Gesso and Gel Medium

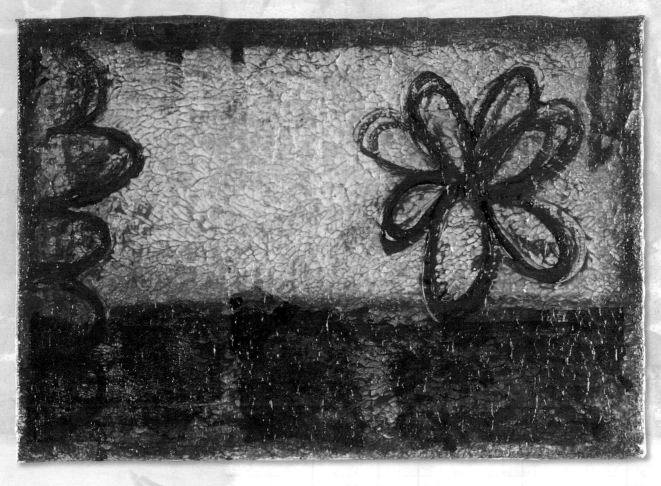

MATERIALS

Substrate such as canvas or wood
(I used canvas board)

Gesso

Gel medium

Texture makers (plastic shopping bag,
bubble wrap, paper towels)

Old credit card, sponge brush or
palette knife for spreading mediums
(or use your fingers)

Optional: collage embellishments,
such as thin papers

Shari Beaubien's take on textured backgrounds resonated deeply with me. I love the idea of "all over" texture to begin a painting. When trying out this technique myself, I couldn't help but doodle my signature daisy right into the wet gesso before it dried. Follow your own urges! You never know what will spark a new idea and guide you toward your own signature style elements.

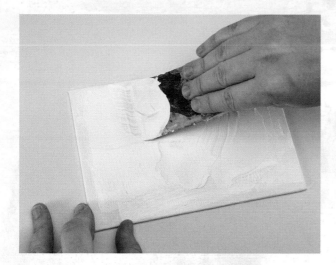

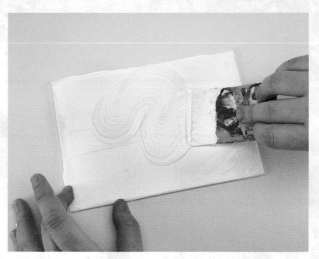

1 Prep your substrate (I used canvas board) with a thick layer of gesso using an old credit card, sponge brush or any tool you love to use. I achieved more coverage and thicker gesso with the old credit card.

2 Create various patterns and swooshes in the wet gesso with the old credit card or any other texture tool you choose. Consider marking into the gesso with everyday objects like a wide, dry paintbrush, corrugated cardboard or even a chopstick.

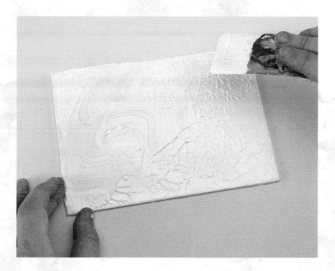

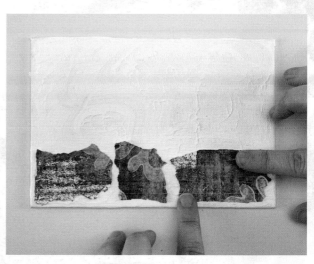

3 Try pressing the card into the gesso and lifting it straight up to make a rough, peaked texture. If you notice any of the peaks are too high, or you want less texture, smooth them out a bit. Allow the gesso to dry completely, which will take a few hours.

4 You can add your own unique touch by collaging in some of your favorite papers. You can use any thin paper; sheet music, old book pages, tissue paper, telephone book pages and hand-painted papers work well. Here, I'm using hand-painted papers. Just apply a thin layer of gel medium where you want to collage and press your paper bits or ephemera down into the gel medium.

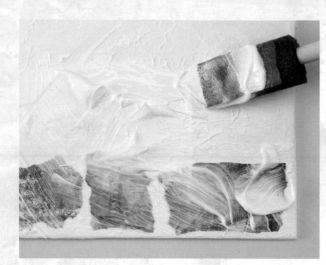

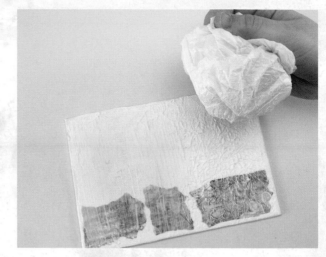

5 Add a thick layer of gel medium. Glop it on! Cover the whole surface. You want it to be thick enough that when you press into it, you get a nice texture.

6 Crumple up a plastic shopping bag and do quick presses into the gel medium. You could also use bubble wrap or a paper towel—anything that creates a texture. I really like the texture that a plastic bag gives.

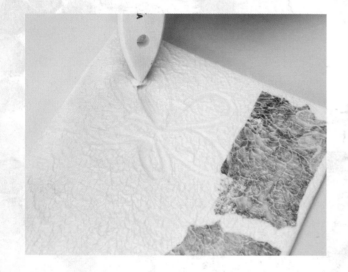

7 Try using a pointed object to draw textures or marks into the wet gel medium. I'm using the wrong end of a paintbrush to add my signature doodle daisy.

8 Allow the gel medium to dry completely; then you're ready to paint. I've found thin, almost watery acrylic paint works really well when painting on such a textured surface. Golden Fluid Acrylics are my go-to thin paint, but you could also dilute your favorite acrylic paint with water or a glazing medium to achieve similar results.

Transfer an Image With Gel Medium

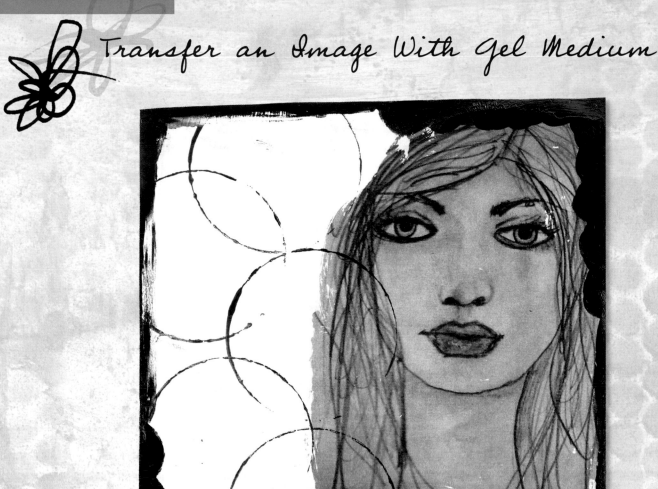

MATERIALS

Something to paint on (I began on spiralbound scrapbook paper)

Image to transfer (laser-printed or photocopied)

Gel medium

Pencil

Rag or paper towel

Water (in a small spray bottle or sponge)

Optional: old toothbrush, lint-free rag or sponge; polymer medium; cardboard or similar surface; brayer or spoon

In the last demo, you saw how gel medium was used to attach collage elements and create background texture. This versatile product can also be used for image transfers. This transfer technique gives you a really clean image. I like the extra layer of medium it puts down that I can then build upon. It is also a safe transfer to do indoors. (I avoid solvent transfers with my kids around.) I use a lot of my own photos and sketches for transfers. Magazine images work too, though be aware of copyright issues if you're planning to sell your art. There are lots of royalty-free images out there; look online or ask friends. Most government images are royalty free (visit www.usa.gov/Topics/Graphics.shtml for more information and photos).

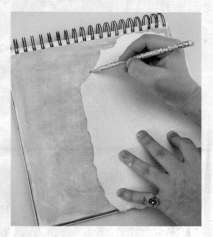

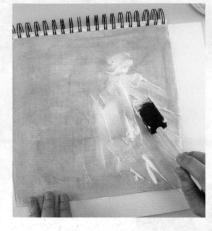

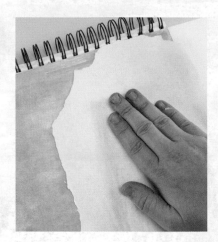

1 Position the image where you'd like it to be on the background. Trace around it with pencil very lightly. This will help you know where to put down gel medium.

2 If you're working in an art journal or anything else with pages, protect the other pages by slipping some cardboard or another surface behind the one you're working on. Spread the gel medium just inside the penciled lines, covering the entire area. Spread on a fairly thick, even coat, making sure it's smooth. Some people also apply the gel medium to the image, but I don't because I'm too messy and get it everywhere.

3 Place your image facedown in the gelled area. Smooth out the back of the image. Some people use a brayer or a spoon; I like to use my fingers. Apply heavy pressure, making sure all parts of the image make contact with the gel medium. If any gel medium oozes out from the edges, use a rag or paper towel to push it away from the image. It's fine to get the medium on the rest of your background, but don't get it on the back of the image or it won't pull off properly. Allow to dry completely.

Tips

- You can transfer onto any surface that has been prepped with gesso or a medium, or one that has been prepainted. If you choose paper like I did, be sure to prep it well, or you will run the risk of the surface paper coming apart when you rub away the paper pulp from the image.

- If your image has any writing on it, be sure to print or photocopy it reversed because it will reverse when you transfer it.

- The bolder the colors and the more solid the lines in the image you're transferring, the better the transfer will work.

- White transfers as blank because there's no ink.

- The lighter the background you're transferring onto, the better your image will show up.

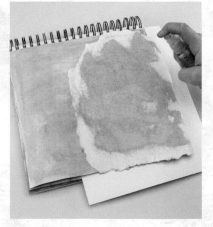

4 Wet down the image completely. I like to use a spray bottle, but you could also use your fingers, a sponge or a damp cloth. Let it sit to let the water really soak in.

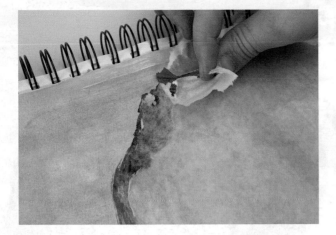

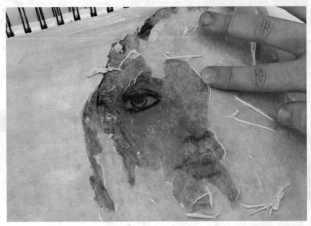

5 Rub all over the area with your fingers. The paper will begin to rub off as you work. Tear off the edges as they loosen.

6 Once the paper begins coming off, you can keep using your fingers to remove it, or use a lint-free rag, a sponge or a toothbrush. Continue adding water as necessary as the paper starts to dry again.

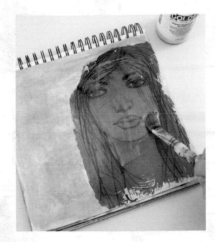

Also try transferring more generic images, such as newspaper ad pages, to create backgrounds.

7 Sometimes when you've finished and the entire piece has dried, you'll notice some areas where the paper pulp hasn't all rubbed off. Add more water and rub off these areas. Allow to dry completely.

8 I like to apply a coat of polymer medium over my transfers to seal them. I'm pretty aggressive with my artwork, and when I'm rubbing on my art later to remove paint or other things, I'll rub the image transfer off in the process if there's no protective coat. If you apply a thick layer, you can scratch designs into it.

Jessica Swift

My style has evolved a lot over the past six years or so. I think the underlying elements have remained constant, though, which ties it all together. For example, color has remained central to my work throughout the changes, as has my interest in natural shapes and themes.

My work has become more personal and evokes more of a message than it used to, which I think is directly related to my own growth as an adult. I've learned about myself through my art and vice versa. A couple of years ago, my work also unexpectedly took a figurative direction; all of my previous work was based in nature and travel in cities. This was a big surprise to me.

I find inspiration everywhere—people in interesting outfits, seeing colors combined in a way I never thought of, overheard snippets of conversations, Anthropologie catalogs, looking back through my old work—and often I'll just start drawing or painting, and the inspiration will come just because I *started*. I think you can make the right

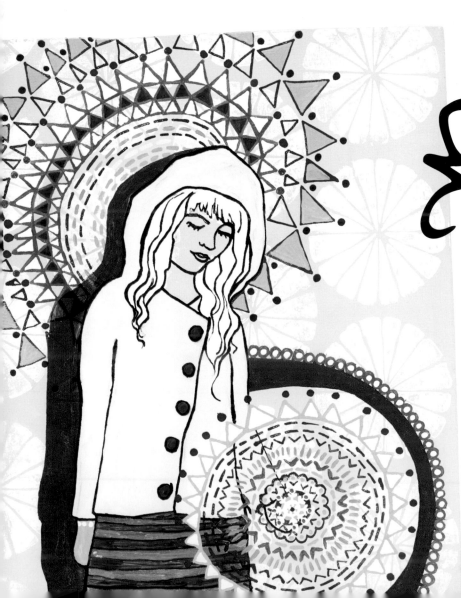

A couple of years ago, my work also unexpectedly took a figurative direction; all of my previous work was based in nature and travel in cities. This was a big surprise to me.

We Are All Snowflakes

Jessica Swift

Acrylic, oil, India ink and block printing on fiberboard

10" x 8" (25cm x 20cm)

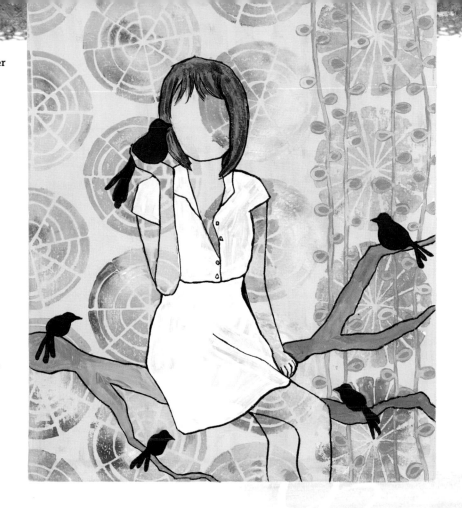

Birds of a Feather

Jessica Swift

Acrylic, India ink and block printing on fiberboard

10" x 8"
(25cm x 20cm)

conditions for inspiration to come in instead of waiting for it.

The main thing that never fails to get my creativity flowing is going outside to take a walk. I am so inspired by nature, and the ideas that flow into my head are always so unexpected that I find myself wanting to run home to write them down or start a new project. I also love flipping through books, photographs and catalogs with beautiful images, because I never know when an image or a phrase will hit me and cause an idea to form. But walking and being in nature is the main thing.

I have learned to trust myself, and I am slowly learning that I have good ideas that are worth putting out into the world. I never used to think my work meant much of anything, other than being pretty to look at. I'm growing into the idea of being a creator more and more, and I'm thinking about what I want to put into the world.

The Internet and the blogging world have affected my evolution as an artist tremendously. When I first started out on this path, I didn't know many people

who made a living as an artist, and I sure didn't know if it was possible. Now I'm in contact with other artists every day. It's been so inspiring and encouraging, and I'm a huge advocate now for the possibility of making a living as an artist.

I've learned a lot of new skills (pattern design, flash animation) in the past few years as well that have caused me to expand in different directions that I'm completely in love with. I realize now that I don't have to pin myself into one medium, one style—I can do it all!

Play and Possibility

I love the feeling of possibility that all my favorite supplies hold. They're like my best friends, and we just create and create and create together. I love the feeling of being able to make whatever I want with no restraints. I love the smell of paint; a new sketchbook and a trusty pen; the feeling of pressing a rubber block to a piece of wood and that slight stickiness when I pull it up —there are so many things. Just being able to play with my art supplies gives me that giddy feeling!

Print With Hand-Carved Blocks

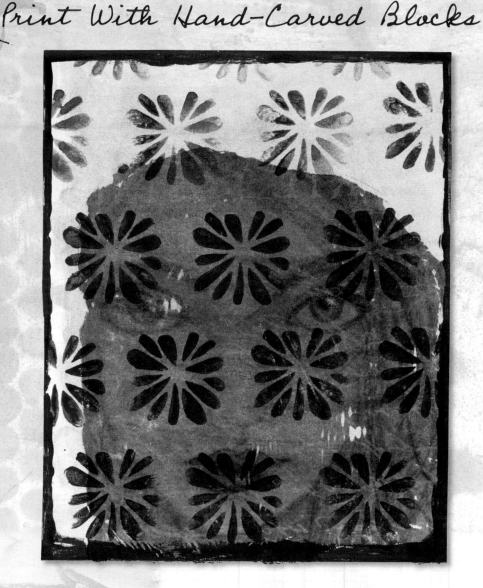

MATERIALS

Block printing kit—linoleum or rubber block and carving tools

Pencil

Block printing ink or paint

Palette paper or wax paper

Brayer

Something to print onto (prepped painted surface, paper, art journal, canvas, etc.)

Optional: spoon

Pattern is a common theme in Jessica Swift's artwork. In addition to creating beautiful paintings, Jessica is a surface-pattern designer. Her hand-carved stamps have given her a unique way to add pattern and texture to her paintings and designs. I like to use my custom stamps to create texture by stamping them into wet media like gesso, gel medium, crackle paste and molding paste. (See page 69 for an example in which I stamp into crackle using a flower stamp I made.) In what other ways could you use your custom hand-carved stamps?

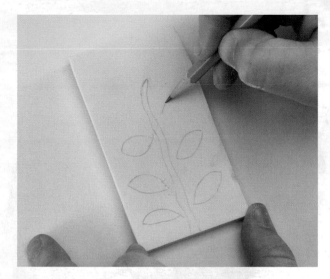

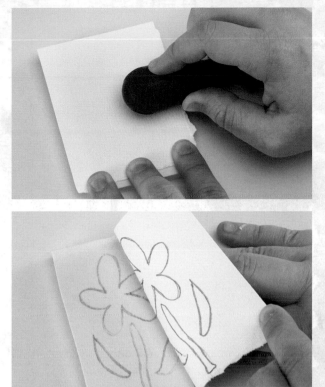

1 Draw your design onto the surface of the carving block. You can use linoleum or rubber blocks; I'm using rubber. Linoleum is a bit harder to carve, but it's sturdier, so it's good for words or small detail. Remember that when you use the block to print, the image will be reverse, so draw it in reverse.

When you lift the paper off, the image will be left on the block.

Tips

Block printing ink is thicker than drawing ink and comes in a few varieties, including oil based or water soluble. Oil-based block printing inks are slower drying and difficult to clean up, but are waterproof and permanent when dry. Water-soluble block printing inks dry fast and clean up easily with water. I like to use paint in place of block printing ink because I always have it on hand and I generally use my custom stamps in my mixed-media paintings.

1 (Alternate option) You can also draw your design on a piece of paper and rub it onto the block. Be sure to press hard with your pencil so the graphite will transfer to the block. If you use this method, there's no need to reverse your words/image because it will be put in reverse onto the block and be reversed back to normal when you print. Burnish with a good amount of pressure to make sure the graphite transfers. I'm using the blunt end of my carving tool to burnish, but you could also use a spoon.

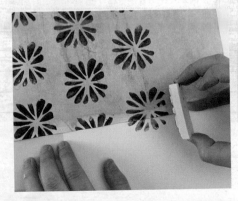

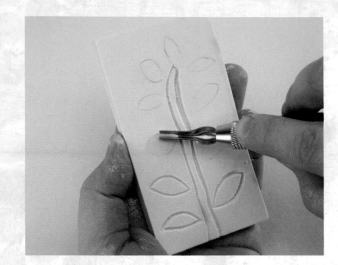
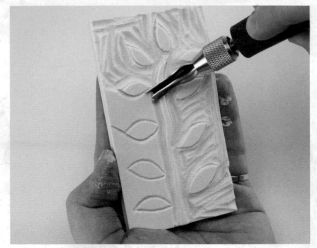

2 Carve the block. Carve along the edges of the image with the smallest V-tip on your carving tool, effectively outlining the image. The carving tool comes with several different tips; play with them all to see which ones you prefer working with.

3 Once you've carved the outlines, go back in with a larger tip to get rid of the bigger areas outside the image. Remember to carve away anything you don't want to show up on the print. Ideally you'll want your image to be raised about ⅛" (3mm) above the areas that are carved away.

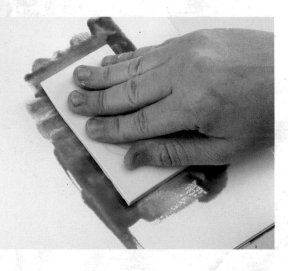
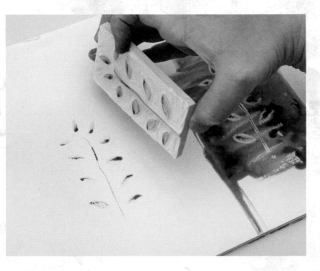

4 Test your stamp right on your palette paper. Pour a little bit of ink or thinned paint on your paper. (If using acrylic paint, you can thin it out by adding some water.) Mix it around and spread it out evenly with a brayer or your finger. Press the stamp down in the ink or paint.

5 Stamp on the other half of your paper to test the image. If the rubber around the edges of your image shows up, you haven't carved it away enough.

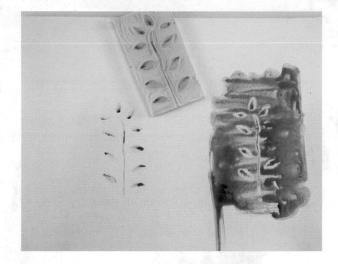

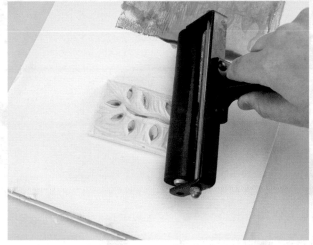

6 Notice how you could also make a reverse image by simply lifting paint away from an area, as you did for the test print.

7 You could also use a brayer to ink your stamp. Roll the brayer in the paint and then roll it across the surface of the stamp. I prefer to just pounce the stamp around in the paint a bit before stamping. Try both ways and see which you prefer.

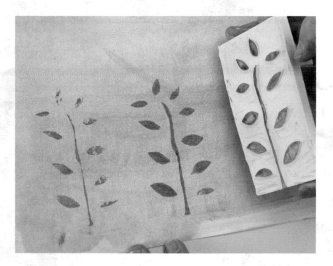

8 Use the stamp in your artwork. Adjust the amount of ink or paint you're using, as well as how hard you're pressing, to get different effects and darker or lighter impressions. Add more paint before stamping again and apply even pressure to the back of the stamp if you want all of your image to show up evenly.

9 To make a pattern, make a row of stamps. Start another row, shifting the placement of the stamp so that they're in between the previous row's images.

Bridgette Guerzon Mills

I have always had a creative bent to my nature, but I never thought that I could be an artist. An artist seemed like some magical, foreign creature that I was not allowed to be. But after a couple stumbling blocks that life has a tendency to throw one's way, I did some major soul searching and knew that I needed to confront this desire to create and see what would happen.

That being said, I am a self-taught artist, and my work has definitely evolved over the years through a lot of hard work and a diligent dedication to my art. I used to think that being an artist meant that one would have these creative visions just appear before her, waiting to be put on canvas. But I have learned that creating a painting is something a bit more organic. It comes through practice. It arrives by coming to the easel or table every day and just working.

By picking up a paintbrush or handling different papers and images, the ideas come and the work happens. You cannot just sit and wait and hope to be inspired. Of course, bolts of artistic inspiration can happen and are very appreciated! For me, though, my inspiration is usually more subtle, and I have learned to keep my eyes, ears and spirit open to those whispers.

I call myself a mixed-media artist, meaning that I use a variety of materials in one painting as well as switch between media. I paint in oils, acrylics

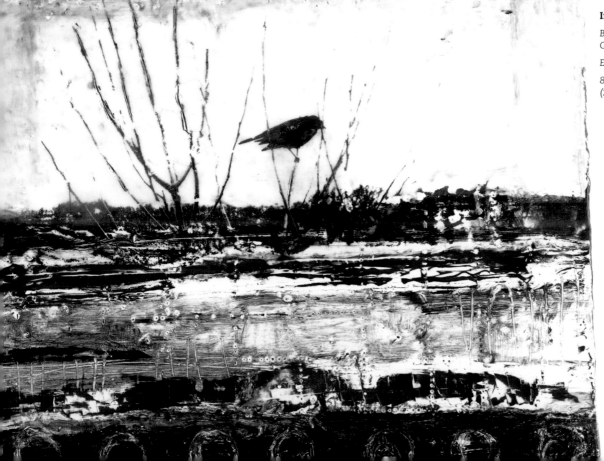

In This Body

*Bridgette
Guerzon Mills*

Encaustic on wood

*8" x 10"
(20cm x 25cm)*

I have developed a personal visual vocabulary that I draw upon in my paintings. The images I use are not arbitrary; there is a reason I use trees, birds and certain plants in my work. There is a reason for the dots, scratches and markings that I use.

and encaustics, and I also make hand-bound books. I like to keep myself open to different creative possibilities, and I really enjoy experimenting with different materials. But if I had to choose just one to work with, I would choose encaustics.

The first time I saw an encaustic painting was in a gallery several years ago, and I knew that I had to learn all about it. It was love at first sight. And of course being a mixed-media artist, I still bring other media to my encaustic work—photographs, oil paints, oil bars, plaster, clay—I just cannot help myself. I love to explore and discover new ways to incorporate all the different materials that inspire me.

Anything and everything contributes to my artwork. I often feel like a sponge, taking in the details and experiences of my daily life; the stories that make up my past; my future hopes and

fears. I take these experiences and feelings, and I wring them out onto my canvas. My paintings are very intimate reflections of myself, yet communicated in a visual language that other people can relate to.

I have developed a personal visual vocabulary that I draw upon in my paintings. The images I use are not arbitrary; there is a reason I use trees, birds and certain plants in my work. There is a reason for the dots,

scratches and markings that I use. These are symbols that I have been working with, and they have special meaning to me and help me get my message across. These symbols are constantly evolving, though, and it is important to be open to that evolution.

Journaling about my paintings as they are completed has been a tremendously useful tool for my growth as an artist. Writing down what I did and why, what I liked or disliked, and different experiments and their outcomes help me to hone in on my vision and what I am trying to say with my paintings. I believe that if you are creating something that is truly coming from within, that is your true vision and authentic voice, then it will speak to other people.

The Encaustic Experience

Encaustics is the perfect fit to translate what is in my head into the visual and physical manifestation that occurs on my substrate. It does what I envision. It is the perfect combination for me of paint and clay. It is nothing like clay, really, but it has that same tactile quality for me. I can incise, make dots, scrape, etc. Some people go for a smooth, glasslike finish with encaustics. I love how that looks, but I revel in the lumps and bumps, the scritches and scratches. I am a texture person, and I can create texture with this medium, as well as embed materials in it to add to the texture. I don't know what it is about encaustics and me, but there is never hesitation.

Transfer an Image Onto Wax

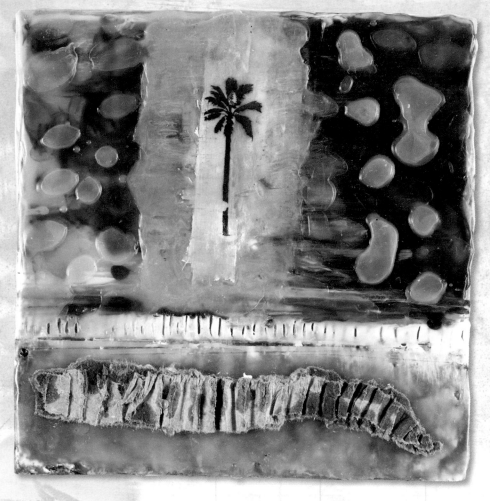

MATERIALS

Sturdy substrate (such as wood, panels or plaster)

Beeswax or encaustics

Melting pot or small slow cooker, designated as just for wax

Photocopied or laser-printed image to transfer (not inkjet)

Natural-hair brush

Small craft iron

Craft heat gun

Spoon or other burnishing tool

Water-filled spray bottle

Bridgette Guerzon Mills captures moments in time and the beauty of her surroundings with her camera and then incorporates her original photography into her encaustic artwork with image transfers. Image transfers are an excellent way to add personal meaning to your artwork, especially if the images include your own photography or drawings. Keep in mind that when working with wax, you'll want to use a firm substrate; a flexible surface will lend itself to cracking. Also, choose an image that has very defined edges. Silhouettes work best.

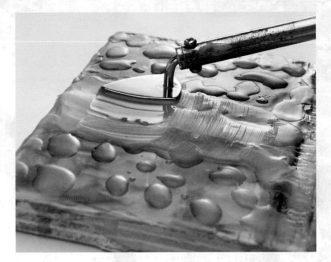

1 Melt the wax in your melting pot or slow cooker. Apply a thin layer of wax to the prepared surface (it may be prepainted, waxed, collaged or encaustic painted) where you want your transfer to be placed using a natural-hair brush. Do not use a synthetic brush; its bristles may melt.

2 Smooth out the wax using a craft iron. You could use a heat gun, which I often do because I'm impatient, but it will move the wax around a lot. The iron is more direct and will smooth out the wax more evenly. Allow the surface to cool so that it's warm, not hot. If it's too hot, it will be too soft and the image will crush the wax. If it's too cold, the wax won't grab the ink. Use a heat tool to rewarm the wax if necessary.

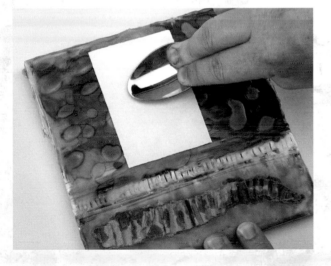

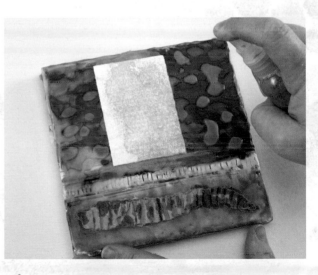

3 Place your image facedown on the warm wax. Use the back of a spoon to burnish the paper, applying even pressure. Make sure to go over the image several times or you will only get a partial transfer. Wax cools really fast, so it will be ready for the next step in seconds. (In fact, you'll need to work very quickly from step to step so you can work with the wax before it cools.)

4 Spray the back of the image with water, wetting it completely, and let it sit for several seconds so the water soaks into the paper.

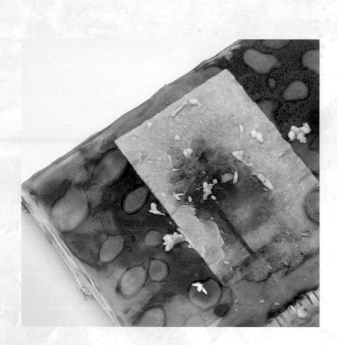

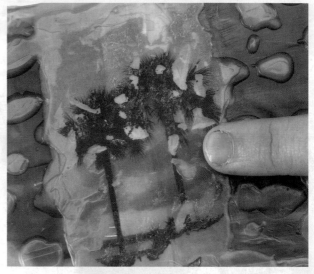

First Transfer Attempt

On my first attempt, the wax where I placed the image wasn't smooth enough, and in this case, the image didn't adhere well. Also, I chose an image that was a little too detailed. Simple black-and-white silhouette-like images with solid edges work best. I'm sharing this result to show that even if you make a mistake, it's fixable. Wax is pretty forgiving.

5 Begin rubbing the back of the image with your finger to start removing the paper. I wouldn't recommend using anything but your finger for this or you may scratch the wax.

Tips

- Whenever working with hot wax, work in a well-ventilated room.

- Be sure to use a natural-hair brush when applying wax, and designate this brush as just for wax. If your brush is synthetic, its bristles may melt.

- After you've done your transfer, don't apply any heat to the art again. Otherwise the transfer will shift and distort.

- You can paint over wax with oil paint. Acrylic, on the other hand, won't adhere well in the long run because it is water-based.

- The technique on page 56 shows how to seal a painting with wax and add surface texture. Adding a transfer over a wax-sealed painting can create another fun visual effect.

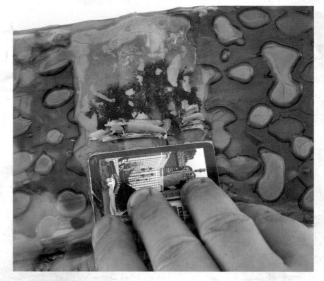

Removing a Failed Transfer

To take off a failed wax transfer, heat the wax up a bit with a heat gun. Use an old credit card, palette knife or anything else you can scrape with to remove the layer of wax where the image is.

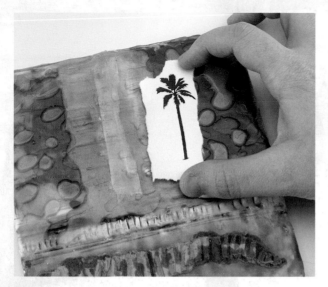
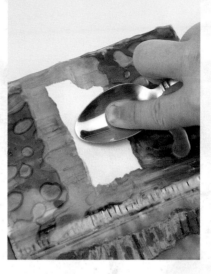

Attempt No. 2: Using a Simpler Image

I repeated the steps with a simpler image, and the transfer turned out as expected. Alternatively, you could select an inverse image to transfer—one in which the shape you want to show is white on a dark background.

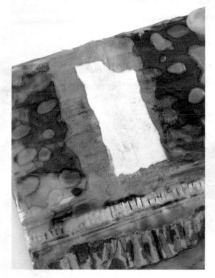
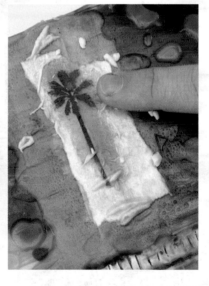
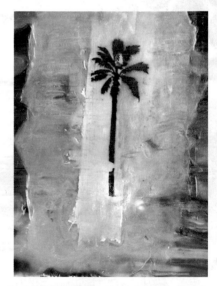

Successful Second Transfer

Seal and Embellish With Wax

MATERIALS

Painting or collage to seal, on a sturdy substrate

Beeswax or encaustics

Melting pot or small slow cooker, designated as just for wax

Natural-hair brush

Small craft iron

Craft heat gun

Smooth, soft, thin cloth

Collage embellishments, such as buttons

Using wax to seal your artwork gives you many options for adding your own unique spin on a finished piece. A beeswax finish has a unique feel that can vary in appearance, depending on how you apply it. You can buff it for a smooth look that's shiny yet hazy. You can embellish the surface by pressing items into it, or modify the surface with texture tools by scratching into it randomly or creating focal points with lines or doodles. What I love most about sealing with wax is that if I don't like the look of the textures I've added, I can reheat the wax to melt it and begin again.

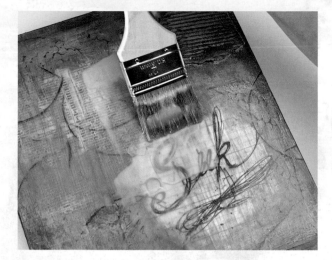

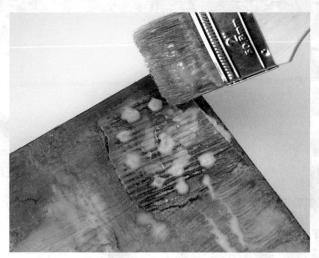

1 This piece began as a mixed-media painting with acrylic, collage and inky writing on wood. Melt your wax in a melting pot or slow cooker and paint a liberal coat onto your painting using your natural-hair brush. Put it on thicker in areas you'd like to embellish and thinner in areas where you really want what's underneath to show through. The thicker wax will have a more hazy finish.

2 Add dots or pools of wax for texture. In places where your piece already had texture, the wax will sink in or rise up.

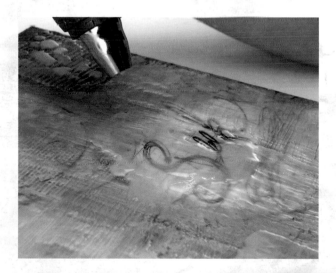

3 Use a heat gun to heat the wax and let it smooth itself out as it settles. Use less heat on areas you want to retain the texture of, but you'll still want to use some heat to fuse the wax.

Tips

- Whenever you work with hot wax, work in a well-ventilated room.

- Be sure to use a natural-hair brush when applying wax, and designate this brush as just for wax. If your brush is synthetic, its bristles may melt.

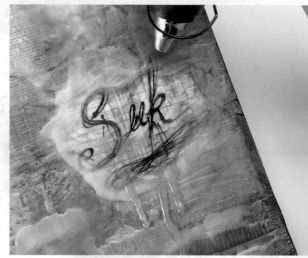

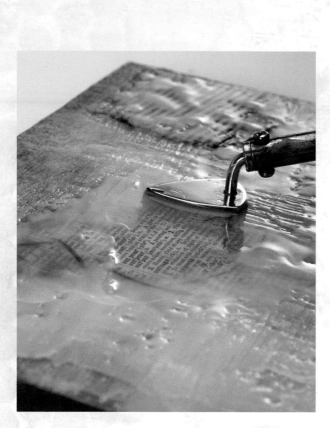

5 Try tilting the canvas as you heat it with the heat gun to get a dripped wax effect or to reveal the layer below.

4 Use your craft iron to further smooth out or thin areas you want smoothed out. Move quickly, as the iron melts the wax very quickly and will go right through it. Here, my iron actually melted the paint beneath a little bit so that it mixed with the wax (an effect I like but that you may want to be wary of). Also, the edges of the iron will cut into the wax rather than spread it if you don't use it flat, which is great for creating texture.

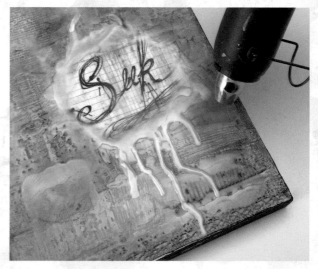

6 If you add a second layer of wax onto a layer that has already dried—here, my dripped wax acts as a second layer—you'll need to go back and fuse the layers together by heating them a bit with your heat gun.

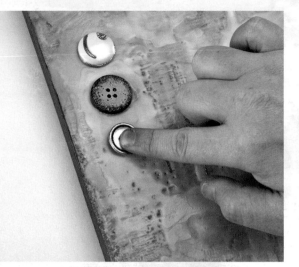

7 You can also stick embellishments into the wax by heating it up and simply pressing them in. If you crush the wax a bit by doing this, just go back later and reheat the wax with a heat gun around the buttons.

8 Use a T-shirt, a rubber glove, or any smooth, soft, thin cloth to buff the wax to a little bit of a shine. It's not a super-dramatic effect, but it looks nice.

Tip

Get really creative with embellishments in your wax. Paper, buttons, flower petals, feathers, beads, fabric pieces and other small, lightweight items work great.

Karin Bartimole

I've always been an artist at the core. As a child I spent hours with hand to paper, creating intricate patterns and designs, my hand ever moving. Early on I learned that my creative process helped me through the stresses and challenges that presented themselves in a home plagued with violence and alcoholism. Making art was the only constant in an atmosphere of chaos.

As an adult, I've experienced a number of physical challenges, including my most recent diagnosis of breast cancer. I have had to listen to my body and follow its lead, adapting to the needs it expresses. I began my career as a sculptor but have found other ways to work as changes to my body have necessitated. Art is my healer, and it is where I find my inspiration and strength. When words fail, images speak.

My style is based on a commitment to being fully aware of and honest to the images that arise within, whether they

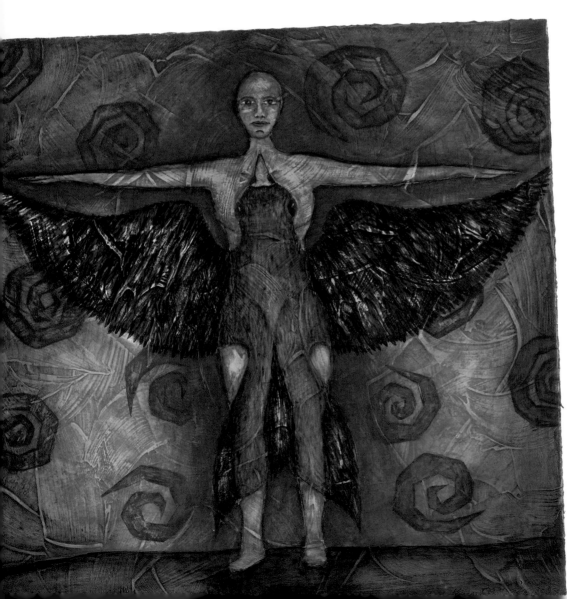

Karin built her painting up from an underlayer of yellow, adding blues, greens and reds while using rubbing alcohol to reveal lower layers strategically.

Stand Fast, Take Flight

Karin Bartimole
Acrylic on paper
10" x 10"
(25cm x 25cm)

come from meditation, from nature, from pain or from joy. I have matured both as an artist and a person as my artwork has become more personal and more spiritually based, reflecting what is within me rather than taken from outside of me. I never create to please another.

My favorite materials to work with are often the least expensive ones out there—from cereal boxes and newspapers to used books, found feathers, bones, sticks and tea bag tags. I enjoy coming up with new ways to reuse and recycle. Even old makeup (lipsticks, nail polish) has found its way into my art bag. Lately I've had a love affair with gesso and acrylic paints, working with them in used books printed in foreign texts that I can't read. I allow the patterns and lines of text to show through like a shadow, adding another layer to the imagery.

Karin used spackle on bookboard along with acrylics and spray varnish to create the textured cover for this 6.25" x 4.5" (15cm x 11cm) hand-bound book.

> *I have matured both as an artist and a person as my artwork has become more personal and more spiritually based, reflecting what is within me rather than taken from outside of me. I never create to please another.*

Reveal Layers With Rubbing Alcohol

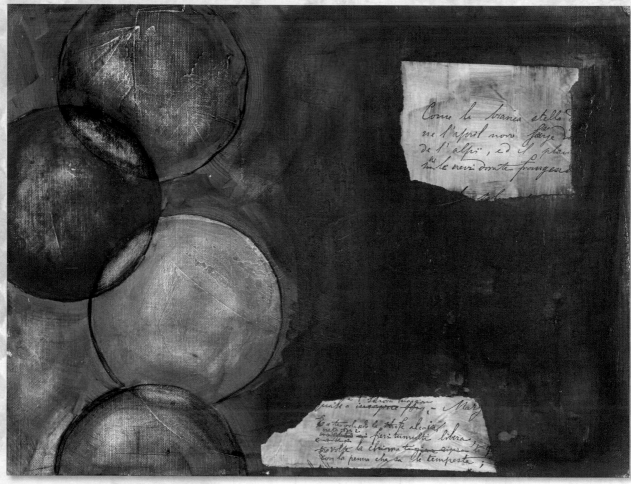

MATERIALS

Substrate (I used acrylic paper)

Gesso

Paintbrush

Acrylic paint in colors you love

Cotton pad or paper towel

Rubbing alcohol

Optional: Acrylic Glazing Liquid (Golden), spray bottle

Karin Bartimole makes beautiful, glowing artwork, often involving a technique that uses rubbing alcohol to reveal layers of paint. The way the alcohol dissolves the paint allows an artist to play with the way the colors show through each other in the finished art. I chose to create something more abstract, using Karin's technique with colors that speak to me personally and my favorite shape—the circle.

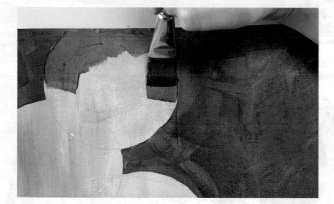

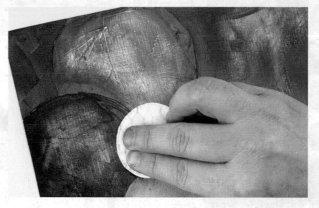

1 Prep the surface of your substrate with a light coat of gesso. Paint on a thin layer of a light-colored acrylic paint. (It is important for the layers to go from lightest on bottom to darkest on top.) Karin uses straight acrylic paint, but I've decided to mix Acrylic Glazing Liquid in with my paints to allow for a little extra transparency.

I chose to paint the entire background of this piece yellow and then sketched out a circle design. When the yellow was completely dry, I began filling in my design one color at a time. I painted over most of the background with burnt orange and then added a second color layer to one of the circles and allowed it to dry.

2 Dampen a cotton pad or paper towel with rubbing alcohol. Gently rub the damp pad across the surface of the painting where you would like to reveal the lower layer. Work carefully—you can always go back and remove more paint if you need to.

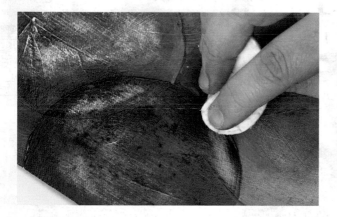

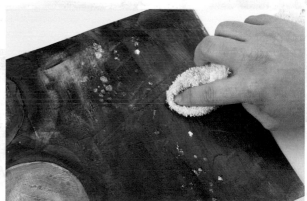

3 Add a third layer of paint over the area that has already been rubbed down to the background layer. Gently remove some of the paint, and bits of each of the first two layers will be revealed. Try removing more or less of the second and third layers for different results. Add as many layers as you like; just remember to add your layers from lightest to darkest, and use this technique to rub away paint after each layer is added.

4 Try spritzing the top layer with alcohol. Allow it to sit for a bit (not too long or it will eat all the way through the layers), and then rub off the alcohol. You'll be left with droplet spots on your painting. You can also paint or stamp with rubbing alcohol right onto a painted surface.

Lay It On Thick With Spackle

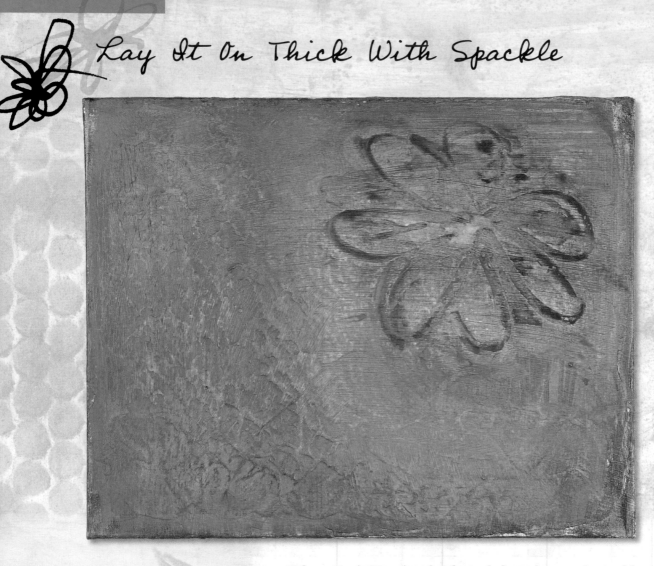

MATERIALS

Sturdy substrate

Spackle

Palette knife

Sandpaper or a sanding block

Gesso

When Karin Bartimole shared that she used spackle on her book covers, my mind started racing. I thought about the possibilities regular household items can lend to artwork. Spackle is easy to find in home improvement retailers or larger grocery stores, and it gives a similar appearance to molding paste and can be used to add texture similarly. Choose a sturdy substrate that won't buckle under your spackle; wood, a book cover or canvas board are good choices. Paper or lightweight cardboard could bend and cause your dried spackle to crack and possibly flake off. Use trial and error to find the spackle you like best for your art.

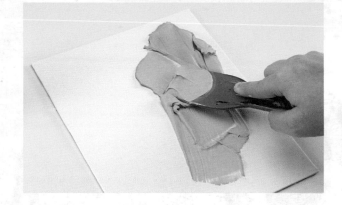

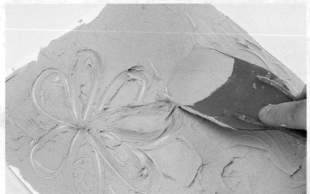

1 The spackle I'll use here goes on pink and dries white so I can tell when it's dry, but any kind will work. Spread the spackle onto your substrate. I use a palette knife rather than a credit card because the spackle's thickness requires an application tool that's a little less flimsy. Put it on fairly thinly; if you put it on too thick, the spackle will crack and weaken as it dries. Smooth it out, working both from top to bottom and side to side to eliminate stroke marks.

2 Draw or write into the spackle with the corner of the palette knife.

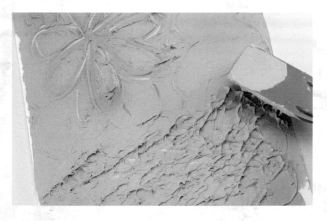

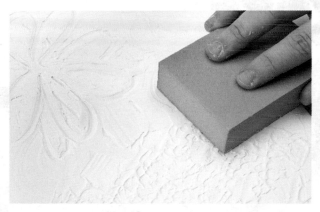

3 Pull straight up and down with the flat of the knife to make little peaks.

4 Allow the spackle to dry completely. (Depending on the type of spackle you use, it could take a few hours or overnight to dry. Follow the recommendations on the container.) Then, sand the surface down a little with your sandpaper or sanding block to smooth out the peaks a bit. Don't sand too hard or you'll get rid of all the good texture. Before you paint on your newly textured surface, add a light layer of gesso. Spackle is rather absorbent, so the paint won't show up as well if you don't. Try using your favorite acrylic paint. I used thin acrylic paint on my piece.

Carmen Torbus

When I started working with the contributing artists for this book, I wanted to know what makes them tick. I asked them questions like, "What gets your creative juices flowing?" and "What do you know now that you wish you had known then?" I asked them to allow us to peek into their bag of tricks by sharing their favorite supplies and tools. I asked how they use them and why. Then, most importantly, I asked them to share their passion, heartfelt stories and their art. You see, I believe that the passion behind what they do and their personal stories offer up pieces of themselves into their artwork.

Each contributing artist inspired me long before I asked them to be a part of this book, but they rocked my socks off with what they shared. Their unique artistic styles are truly a reflection of who they are—amazing artists and women. Speaking of amazing women, as my editor, Stefanie, began putting all of the bits and pieces of this book together, she asked me to answer the same questions I had posed to the contributors. I hadn't realized how hard it can be to really self-reflect and try to identify what makes my style my own.

So, what gets my creative juices flowing? Where do I find inspiration? How has my style evolved? How have I evolved as an artist? What do I know now that I wish I had known then?

I'm a sucker for craft stores, office supplies and inspiring words. Nothing lights me up more than hearing others say

Hope
Carmen Torbus
Collage, acrylic and ink on canvas board
8" x 10" (20cm x 25cm)

I know now that I am an artist; it would have been cool to know that "then," but it wouldn't have made this journey nearly as fun as it has been.

My Own Yellow Brick Road
Carmen Torbus
Acrylic and collage on canvas board
16" x 12" (41cm x 30cm)

they are inspired. Being around positive and encouraging women always inspires me. I'm a cheerleader to my core, and I love connecting with creative dreamers and collaborating with other artists, so creating this book has been an incredible experience.

Creating artwork that expresses my thoughts and moods is powerful. I love looking back at art I've created and being able to remember how I felt or what I was experiencing in my life when I was painting it. I also love incorporating meaningful images and words in my artwork. It's almost like taking a photo to capture a memory. My artwork often captures my emotions.

My style is still evolving—and I love that—but there are certain elements and color combinations that I seem to be drawn to. I love

that I'm beginning to feel confident in my choices when it comes to how I create, when I create and why. I know now that I am an artist; it would have been cool to know that "then," but it wouldn't have made this journey nearly as fun as it has been.

My artful journey began with a spiralbound notebook, some craft paints and a few random embellishments. Although the thin, lined paper in the notebook probably wasn't the best surface for the heavy acrylic paint and layers of ribbon and tape I was adding, it was fun and felt like an experiment in creativity.

It didn't take long for me to realize that the right choice for my messy, layered and sometimes aggressive style is heavier substrates such as wood. I like to attack my art with paint and ink

and papers and gel medium and sometimes even a hammer to add texture. As you can imagine, stretched canvas can't hold up to that type of abuse, so I've learned along the way to choose my surfaces based on how I plan to create on them.

As my style began to evolve, I often found myself sketching in my art journal and painting backgrounds. I had tons of pencil sketches and a whole stack of backgrounds, and I wanted to find a way to marry the two. Once I learned about image transfers, it occurred to me that using my sketches on top of my backgrounds would be perfect for my vision. When I did this, my style began to evolve and I began to feel like there was more of me in my artwork, and that is a great feeling.

Create a Crackled Appearance

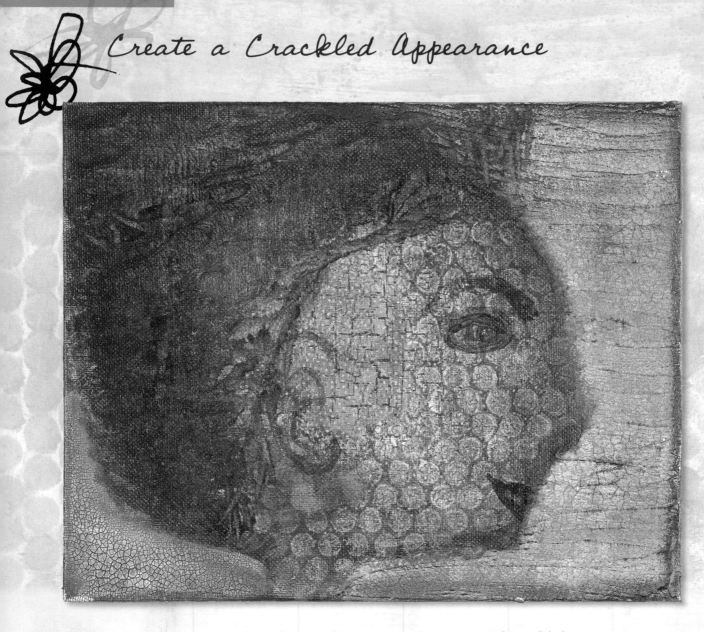

I love random and unexpected texture and combining textures in my artwork. I often add bits of crackle around the edges of my artwork. You might consider covering a substrate completely with crackle medium before beginning a painting, or adding crackle here and there or just on specific visual elements. There are no rules. Crackle comes in several brands, and each one works a little differently and has a different appearance when dry. I'm going to show you a few of my favorites, shown on the same piece.

RANGER DISTRESS CRACKLE PAINT

This one's a simple one-step process. The product comes with a brush in the bottle—nothing else needed for application—and it comes in a wide variety of colors. You can use it on paper, cardstock, canvas, chipboard—pretty much anything. It dries fairly quickly, and once it starts to crack, you can speed it up with a heat gun (if you're impatient like me).

1 Use the bottle-top paintbrush to paint the crackle onto your piece. The thicker the layer you put on, the deeper the cracks will be. Let it dry.

2 I sometimes like to stamp into this type of crackle before it dries, creating a relief of the stamp into the crackle.

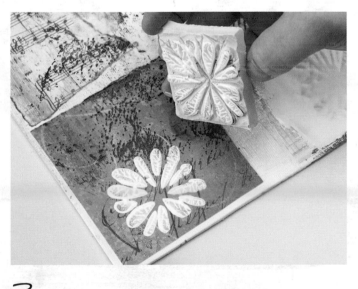

3 I also like to put crackle paint on the stamp and use it to add texture to my paintings.

PLAID CRACKLE MEDIUM

This product has a two-step process, but it produces fairly good cracks and is very inexpensive. If you're painting something large, like a wooden shelf or door, this is an affordable way to do it and get decent cracks. It's lso a good if you want the layer beneath to show up because the underlying color becomes visible as it cracks. This is not necessarily the case with the other types.

MATERIALS

Prepainted surface

Crackle Medium (Plaid)

Paintbrush

Paper towel

Acrylic paint

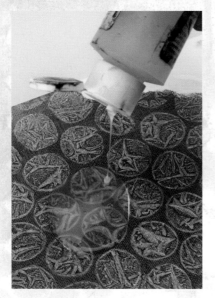

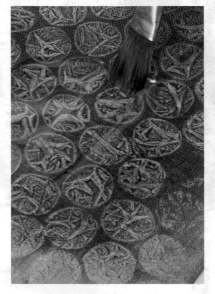

1 Squirt some of the fluid directly onto your prepainted (or collaged) piece.

2 Spread the fluid around as you'd like with a paintbrush. It will pretty much even itself out. The thinner the coat, the smaller the cracks will be. If you put on too much fluid, dab it off with a paper towel and smooth out what's left with the paintbrush. Allow to dry completely.

3 Apply acrylic paint over the entire area where you applied the crackle medium. The acrylic layer you are adding will start to crack as you paint.

GOLDEN CRACKLE PASTE

This high-end, high-quality product is my favorite. The layer you apply can range from really thin (⅛" [3mm]) to super-thick (1" [25mm]), and you can paint on it after it's dry. It's a pasty product when it goes down and works like most Golden-brand mediums do, laying down a good foundation that you can build upon.

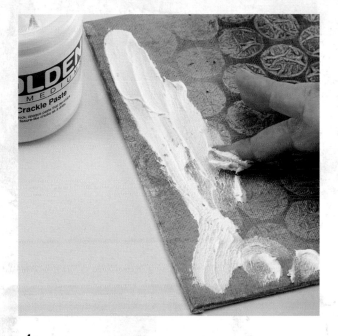

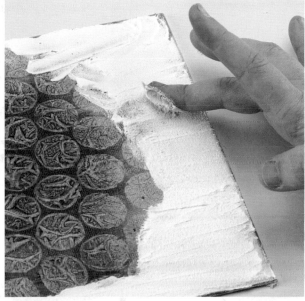

1 Apply some crackle paste to your painting. I like to use my fingers to apply the initial layer, but I like using my fingers for anything I can, so feel free to use a paintbrush or a palette knife.

2 Smooth out the paste with your fingers or a paintbrush. Let it dry completely. Depending on the thickness of the layer, this can take several hours. Do not attempt to speed the drying time with the Golden Crackle Paste or it will not crack. It's important that it dries from the inside out.

Try Out Various Backgrounds

No one can make you feel inferior without your consent.
~Eleanor Roosevelt

Like the lettering of the Eleanor Roosevelt quote? Flip ahead to page 107 to see how it was done.

dreamer...

Backgrounds are a great opportunity to get your feet wet, mix and match techniques and ideas, and just play. You can let loose and not worry so much about the results. You can use the backgrounds you create in a variety of ways, including for art journaling, for the foundation of mixed-media work, or for collage and abstract pieces. What some consider backgrounds, others see as finished pieces of art.

INKED BACKGROUNDS

Aimee Dolich, whom you'll meet on page 104, says her inked backgrounds began as a "happy accident" when she spotted some lonely ink pads and wondered what would happen if she dabbed them directly on a collage. Her discovery? Instant color. You may work with any ink pads you like. Pigment inks will take a little longer to dry than dyes, but will give you archival quality. Dye inks, on the other hand, offer instant gratification, but might fade if they get much direct sunlight. I've found paper is best for this type of background. If you want to use a canvas, consider collaging the inked paper to it.

MATERIALS

Substrate (I used a journal page)

Ink pads

Optional: items to stamp through
(ex: stencil or sequin waste)

1 Rub an ink pad across your substrate. I'm inking up a journal page. The harder you rub, the darker your color will be. You can also go over and over it again to make the color more saturated. Some ink pads you'll need to push harder; others, more lightly.

2 Let the first color dry. Mix and match colors. If you're using your ink pads for backgrounds, I wouldn't count on them staying nice, so you might consider keeping a set that you use just for backgrounds.

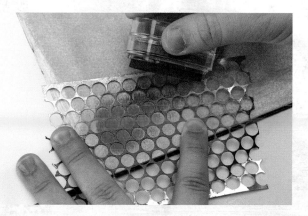

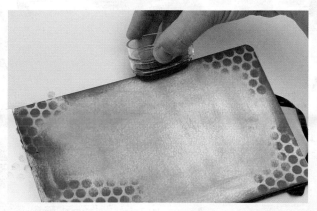

3 Try stamping through stencils, sequin waste or found items to make patterns.

4 I like to rub extra ink around the edges of the paper.

WATERCOLOR BACKGROUNDS

Like inked backgrounds, watercolor backgrounds are quick and easy. You may use any watercolors you like for this technique, but I prefer the tube kind. I also keep children's watercolor sets handy; they are very inexpensive and yield great results for backgrounds like this. I colored a journal page here, but you could also use canvas, and of course, watercolor paper is absolutely ideal for watercolors. I love being able to apply color to my journal pages or watercolor papers to incorporate into collages.

MATERIALS

Substrate (I used a journal page)

Watercolors in colors of your choice

Paintbrush

Water-filled spray bottle

Optional: paper towel, salt, items for stamping

1 I like to take multiple colors and squeeze them right onto the page together. Then I don't need a palette.

2 Add water directly to the page with a small spray bottle or paintbrush. Then start smearing the colors around.

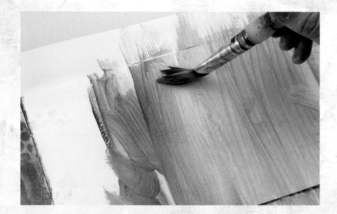

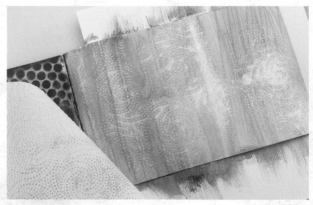

3 Blend the colors together. The more water you add, the easier it is to move the colors around and blend them together but the lighter the color will be. So, be mindful of the amount of water you add if you want more saturated color.

4 You can lift textures with items such as paper towels. Spritz the paint with water, press the paper towel into it and then peel it back.

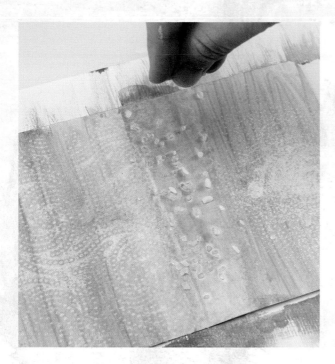

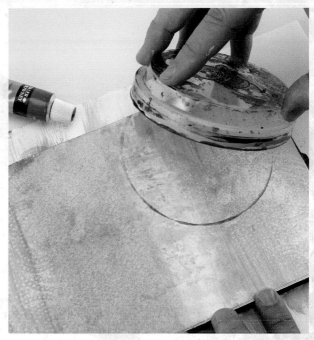

5 Here, I've added some yellow and sprinkled salt on the page. (I'm using bath salt, but any salt will work.) The salt will absorb some of the wet paint as it dries and leave a neat effect. If you don't see the salt working, lightly spritz the page with water. After it dries, brush the salt off, and you will have a unique pattern.

6 This is my favorite tool in the whole world—the lid off of a frosting container. Any lid, stamp, cookie cutter or other shape maker will work. Mix some paint and water on a piece of scrap paper or a palette and coat the lip of the lid. Stamp onto your background to add shapes.

Tips

As far as I'm concerned, you can't mess up a background. Just work right over any area you don't like, or if you feel it's a total disaster, you can gesso over it and begin again.

ACRYLIC BACKGROUNDS

This background technique could end up making an entire finished piece as you layer paint and add your own unique touches. Keep in mind as you layer paints—especially opaque paints—that if you blend too many colors together, you'll end up with muddy color. Allow each layer of color to dry completely before adding another. I love working with thinner transparent paints when I'm creating backgrounds, but try different kinds to see what you like best. I used canvas board here, although you could use just about any substrate for this type of background.

MATERIALS

Substrate (I used canvas board)

Acrylic paint in colors of your choice

Paper towel

Water-filled spray bottle

Paintbrush

Optional: soft rag, items to stamp with (likecorrugated cardboard)

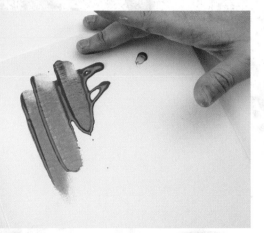

1 Pour some paint onto your canvas. I like to use my finger to smear it around.

2 Use a paper towel or soft rag to rub it around, blend it in and add some texture.

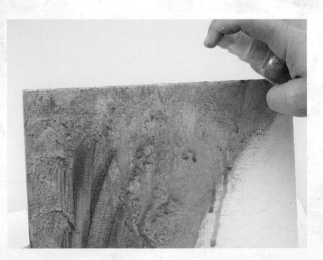

3 Spray the paint with water and let it drip.

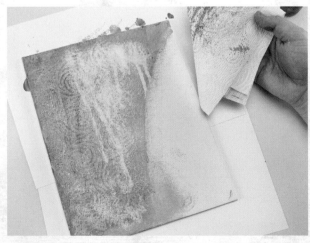

4 Lift some of the paint off with a paper towel or other item.

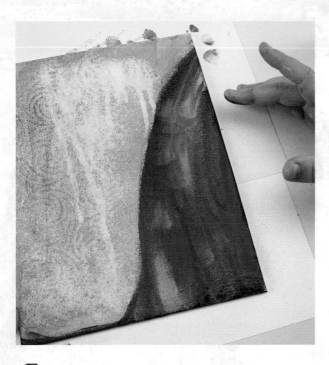

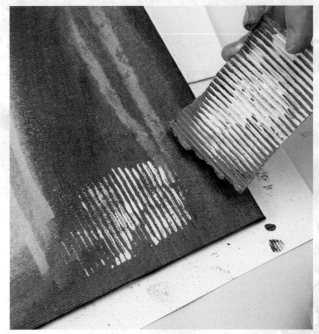

5 Add another color, spreading it with your fingers or brush. Blend it into the other color where they meet. Add water to thin it for a watercolor effect if you like. (Try different things; get creative!)

6 I love using corrugated cardboard (like from the inside of a cardboard coffee sleeve) to create visual texture. I apply the paint directly to the cardboard and use it as a stamp. You can also use it to lift paint as done with the paper towel.

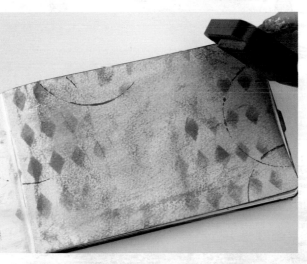

Combining Mediums for Backgrounds
You can combine any of the different mediums shown in these demonstrations to make backgrounds. Here, I'm adding ink to introduce a different color to a primarily watercolor background.

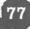

Mystele Kirkeeng

In the autumn of 2007, I hit a brick wall called depression/burnout. I had no desire to do anything creative and sort of fell off the face of my world.

In time, I began to revive, and by January 2008, I was ready for something new, some fresh way to express my creative self. I casually mentioned this to God, and he said, "Why don't you try sketching?" I said "OK," and went about my day without mentioning it to anyone else. The next day, I received an invitation to join a doodling-sketching group on Flickr.com. Knowing that no one else on the face of the earth knew about my little conversation with God, I took the invitation as a confirmation that I'd heard God correctly. So I promptly started sketching,

What I wish I would have really understood in the beginning is what a privilege it is to be able to contribute my unique perspective—my story—to the collective story.

which led to painting, which has led to now, and I haven't looked back since.

When I first began painting, my characters were very whimsical. As time went on, I made it a point to give myself lots of room to play and discover just what I could do. I painted everything from whimsical to realistic.

Recently, I've settled into a creative rhythm that has actually brought me full circle. I still like whimsy and folk art, but the way I approach my characters has changed based on all the things I've learned along the way. I am committed to always stretching my artistic eye, but now I have a solid handle on the elements that shout, "Mystele!" That's a super feeling.

For inspiration, I like to surf through art magazines, Flickr.com and blogs, and watch YouTube art videos. I also look for stories in the characters from my everyday life.

I love quiet and being alone. The solitude affords me the opportunity to think more clearly, and calmly feel my way into what's next. The next best thing is a yummy background waiting for a story to be told!

What I wish I would have really understood in the beginning is what a privilege it is to

Creating Layers of Story

My hands-down favorite supplies are drawing tools, heavy body paints and anything that helps me create layers of story. I love to draw, so anything that helps me scratch out a character is fair game, including things like a stylus or the tip of a palette knife. Heavy body paints suit the messy heft that I like to see on the surface, and they also go hand in hand with my need to create layers of texture and interest. I use items such as scratching tools, hand-carved stamps and stencils in combination with heavy-bodied paint to get just the right bit of beautiful imperfection that I love to evoke in my paintings.

be able to contribute my unique perspective—my story—to the collective story. There is only one "me," and it's so stinkin' cool to see how my art is received by viewers and the way God uses it to speak into their lives. When you really get that, there is just no room or time for self-doubt or comparisons with other artists.

Childhood Memories

Mystele Kirkeeng

Paper, molding paste, graphite and acrylic on cardboard

11.5" x 6" (29cm x 15cm)

Mystele's Method of Using Molding Paste on Cardboard to Build a Background

1. **Choose your cardboard.** A thicker type will hold up to wet media best (my favorites are packing boxes and Capri Sun boxes).

2. **Randomly place papers** (or your choice of collage items) on the cardboard.

3. **Cover the whole surface with matte medium or gel medium.** This will allow you to scrub back to the patterns in your papers if you want, and it also seals the uncovered cardboard areas. This makes the whole piece of cardboard "wet" all at once, ensuring that it will dry flat.

4. **Fill in the gaps between papers with molding paste.** Use a palette knife or tool of your choice. Choose the thickness of your application based on your plans for your painting. Here, I used just enough to meet up with the papers I used, because I knew that I wanted to paint a figure from the background.

5. **Smooth out the paste with a wet palette knife.** This will help the papers and molding paste blend together, but still give a cool variation to the background. You don't **have** to smooth it out; you could just let it air dry and then sand it, if you'd like. (Don't use a dryer or heat gun, though, because the paste needs to dry from the inside out.)

6. **Let the painting begin!** Make a mental note of areas where you want to keep any patterns peeking through the painted layers. If you accidentally paint over them, you'll be able to gently scrub back to them with a wet brush or wet wipe. Another option is to treat the papers and molding paste purely as texture elements, which is what I generally tend to do. In this case, I did save a bit of a vintage atlas piece that shows through the window.

7. **Play with paint and whatever mediums you'd like to work up your background till your heart's content.** Then let it all dry.

8. **Feel around the background to intuitively search for your subject.** Look for shapes of things that speak to you. Once I narrow down the shapes I want to work with, I sketch them out of the background, but you can also just begin painting them.

79

Manon Doyle

My creative juices start flowing in many ways, but mostly with the things I see, how I feel and what I perceive. The moon, the sun and hearts seem to be recurring themes in my work.

I find inspiration in nature, color and people. My style and my mediums have changed over the years, but my love of bold colors remains constant.

I love to paint on canvas, birch wood and Gessobord. I also use watercolor journals for my journaling. My journals always get a few coats of gesso before I start painting. Gesso enables you to use a ton of layers without ruining the paper. It is also the perfect product if you don't like your painting; you can coat the work with a few layers and start again.

I use both the heavy-bodied and fluid acrylics; marking pencils in every color (these pencils will write on anything); and soft gel (matte) to glue down any collage pieces. Molding paste is a great way to achieve texture in a painting. There are many different types of paste, and I think I have them all. Make sure you let it dry completely before painting on it.

Evolving as an artist and a person always affects my artwork. It's always in a state of change. I found my current style through journaling, when the women I painted started to reflect myself. The whole process became very therapeutic for me. I not only discovered my true passion as an artist, but, most importantly, I found me.

I wish I hadn't spent years trying to please others with what I was producing, but eventually I realized that what was feeding my soul was the ability to paint what I felt inside and what my heart desired. This changed my artwork completely.

Fire Inside

Manon Doyle

*Mixed media
on cradled board*

9" x 12" (23cm x 30cm)

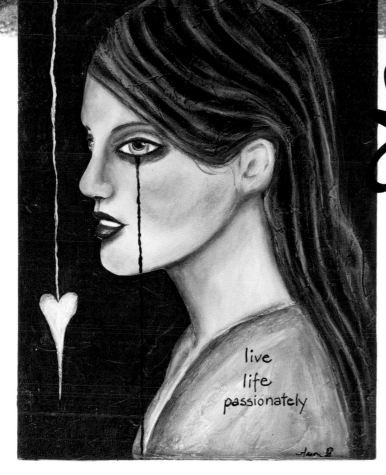

live
life
passionately

My style and my mediums have changed over the years, but my love of bold colors remains constant.

Commitment

Manon Doyle

Mixed media on watercolor paper

12" x 9" (30cm x 23cm)

How Manon Makes a Texture-Terrific Background With Molding Paste

1. **Start with a couple of layers of gesso.** *Let each layer dry before applying the next. Some people sand between layers, but we're not going to.*

2. **Next comes the molding paste.** *You can take a palette knife and spread it on, or even use an old credit card. Once the molding paste is dry, add another layer of gesso so the molding paste has some tooth.*

3. **Once everything's dry, start drawing in the face or whatever you choose.** *Sometimes I do this after my background is done. You can also glue down magazine or book text with your soft gel.*

4. **Choose your favorite colors for the background, something that speaks to you.** *Don't spend too much time fussing because if you don't like it, you can* always gesso over it. Don't totally cover your text. Once the first color is dry, come back in with a different color. You can rub off some of that color while it's still wet so it will highlight your texture. Spatter, spray or even drip paint if you like—it will all add variety to the piece. I then paint the figure.

5. **This is when you can add different elements to your piece.** *I put in what speaks to me on a given day. I often add a heart or ladder. What you feel, you can paint or collage in.*

6. **Add some text if desired.** *Whatever you want to say, write it. You can use marking pencils, permanent pens or anything you have laying around.*

Use Molding Paste With Texture Tools

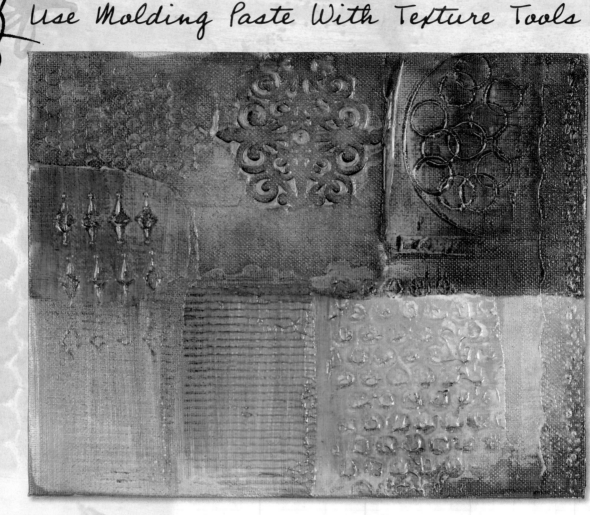

MATERIALS

Substrate (I used canvas board)

Molding paste (I used Golden)

Texture makers: sequin waste, stencil, lace, bubble wrap, cardboard coffee cup sleeve, lids, rubber stamps

Mystele Kirkeeng and Manon Doyle use molding paste to develop the unique backgrounds in their artwork. Here, I'll show you just a few of the different items you can use to create various designs, patterns and textures in molding paste. Molding paste dries white, while gel medium dries clear. You can mix color into molding paste before using it, or you can paint over it. Molding paste takes a long time to dry, so you've got a fair amount of time to work with it (the drying time is similar to gel medium). Choose a substrate that's sturdy and won't buckle or give much, such as canvas board or wood. If you use a flexible substrate, such as paper or stretched canvas, you run the risk of your molding paste cracking or chipping off.

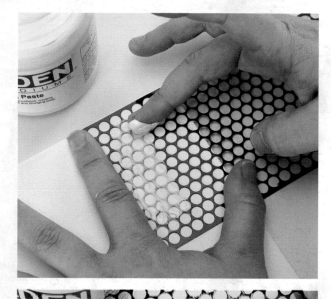

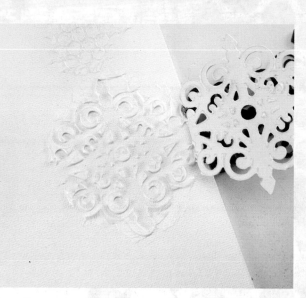

Stencil

My "stencil" is actually a felt scrapbooking embellishment that I simply didn't pull the backing off of. I use this both to stamp into molding paste and to put molding paste through for two different effects.

Sequin Waste

Lay the sequin waste where you'd like the texture. Use your finger to rub the molding paste right across the top of it so it's kind of smooth. Lift to reveal the texture.

Lace

I like to use lace texture for borders often. This is a fun way to give a twist on the popular scalloped border. If you want to reuse the lace, you could soak it in water to salvage or use it when it dries as a stiff embellishment.

Tip

Molding paste can be used similarly to the gesso background technique shown on pages 38–40.

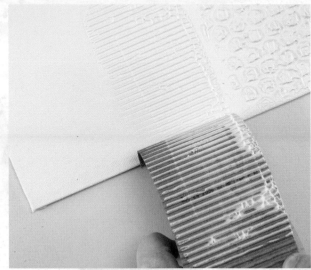

Cardboard Coffee Cup Sleeve

Coffee sleeves are a real must-have supply because they're so versatile. Plus, they come cheap (Free with your coffee!). Use the molding paste that sticks to the sleeve to stamp with.

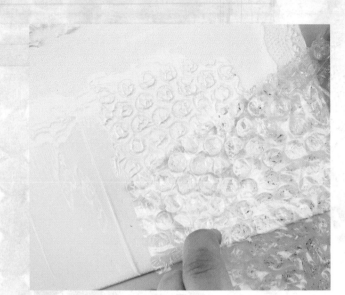

Bubble Wrap

Press the bubble wrap down into the paste and lift.

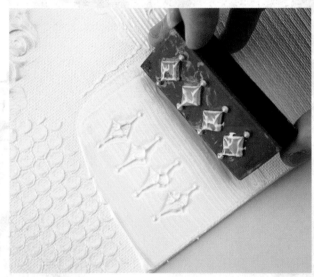

Rubber Stamps

Make sure to clean your stamps immediately after using them. Molding paste is much harder to get off once it dries.

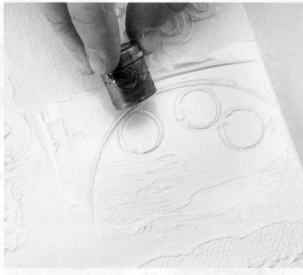

Lids

Use lids of any kind to make circles.

Thicker Than Water

Carmen Torbus

Molding paste and acrylic on canvas board

7" x 5" (18cm x 13cm)

Tips

1. **You can mix acrylic paint color into your molding paste before using it.** *If you're going to combine paints and pastes from different manufacturers, test before you paint to make sure you're happy with the results. I'm much more comfortable mixing Golden paste with Golden paint—rather than mixing different brands together—because Golden specifies that their mediums can be used with any of their paints.*

2. **The great thing about mixing the paint into molding paste is that when you press texture tools into it and scrape the paste away, you can see whatever substrate or other layers you had beneath it.** *Conversely, if you paint over the uncolored molding paste, the raised areas of the paste will show up if you take off some of the paint.*

Christine Mason Miller

When I began my career as a professional artist, my work was very whimsical, colorful and graphic. It is now multilayered, textured and imperfect, with a color palette that is more muted. If you put examples of work I did in the late nineties alongside the work I am doing now, I don't think you would guess it was by the same artist.

Although my mission has remained constant throughout my career—to inspire others to follow their passions and create a meaningful life—my work has expanded to include writing and teaching. I also find myself taking a few steps away from literal expressions of "Follow your dreams" to simply sharing my own journey of following dreams, knowing that will be a stronger example and inspiration than saying it over and over again.

If I am working within a particular theme or idea, I'll scour the Internet and my book collection for images that catch my attention. Beyond that, my travels are a huge source of inspiration; I always return from a trip filled with ideas.

What gets my creative juices flowing? A deadline! I know that sounds very unromantic, but if I have a deadline in front of me, then I must get to work, plain and simple. Even if I don't feel the creative juices flowing when I sit down to start, I start anyway, and then the muses show up to help me every single time.

With collage work in particular, my experience has been that

Be Still
Christine Mason Miller
Mixed media on paper
11.5" x 4" (29cm x 10cm)

> With collage work in particular, my experience has been that the more I try to work on a piece with a specific image or idea in my mind, the harder time I have. My best work comes when I simply dive right in and see what comes up.

Every Day
Christine Mason Miller
Mixed media on paper
11.5" x 4" (29cm x 10cm)

the more I try to work on a piece with a specific image or idea in my mind, the harder time I have. My best work comes when I simply dive right in and see what comes up. This differs from my painting, which so far has been a process in which I need a more focused, intentional approach, because I paint actual images, not abstracts.

Even if there is an overall theme, such as a series of mixed-media pieces I did about a trip to Tokyo, I try to work on each piece from as intuitive a place as possible. I keep an eye on composition and balance, but other than that, I stay loose and open to all possibilities. I do this with a few specific techniques:

- **Working on multiple pieces at a time.** An idea on one piece might light a spark for another piece, and the flow of going back and forth between pieces means I don't get stuck as often. The tiny breaks between each piece give my mind the breathing room needed to stay loose and open.

- **Getting messy—really messy.** I put on grubby clothes, lay a canvas down on my floor and cover any other spaces I don't want splattered with paint. Concerns over "making a mess" impede the creative process; being able to let that go lets me go wild.

- **Silence.** On most days, my studio is totally quiet. I think I am a bit of an oddball in this regard, as music is a creative catalyst for a lot of artists I know, but I usually find it distracting. There are rare occasions when I use it, however. I recently listened to a mix of India-inspired music while working on my latest mannequin form, titled *India*. If I am trying to convey a specific mood in a piece, and I know of a piece of music that will get me in that mood, I won't hesitate to use it.

Your Wings
Christine Mason Miller
Mixed media on paper
11.5" x 4" (29cm x 10cm)

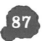

Roben-Marie Smith

When I began my creative journey, I was drawn to vintage style, using mostly browns and few bright colors. I didn't take too many risks and was very structured in my process. Now I am all about color, texture and messy, grungy finishes.

Keeping art journals has been a very rewarding experience for me. It allows me to express myself both visually in a creative way as well as through my words. I use my journals as a place to try out new techniques, paint colors and supplies.

I find inspiration in nature, beautiful fabrics, photography and from so many creative artists.

Paper collage can be a fun and exciting endeavor and a great way to use up scraps of all kinds of papers. Any base piece can be used—just dig through your stash for cardstock, cardboard or any stiff paper item.

I have a huge container of papers, scraps, stickers and labels. When I start a collage, I dig through this container and pull out all the elements that grab my attention. This gets me

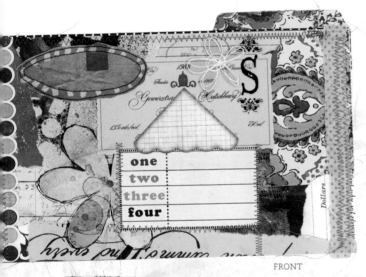

FRONT

BACK

Read This
Roben-Marie Smith
Collage and sewing on file folder
7" x 11" (18cm x 28cm)

Arty Envelopes

I enjoy creating mail art envelopes from file folders to send to friends.

1. **Adhere cut or torn papers** *to the outside of an open file folder.*

2. **Fold the folder to form an envelope.** *Decide which side will be the back and place a focal image on it.*

3. **Add papers, stickers, fabric and other items,** *and then open the envelope and stitch around some images to make them stand out.*

4. **Do the same to the front,** *only remember that you will be placing address labels on it. I like to staple or stitch around fancy labels or large scrapbooking stickers to make them stand out.*

5. **Add rub-ons and doodles around images and stickers** *to pull all the elements together.*

6. **Stitch up two sides of your choice** *(I prefer the zigzag stitch for this). Once your envelope is ready for mailing, stitch up the last side.*

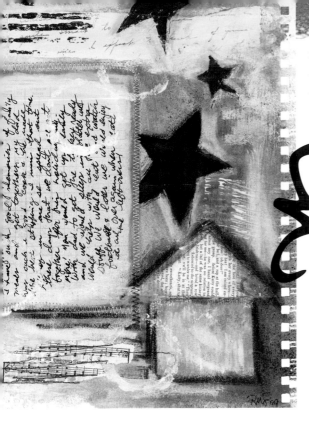

Fond Memories (journal page)
Roben-Marie Smith
Acrylic, spray inks, collage, stitching and oil pastels on paper
12" x 9" (30cm x 23cm)

I used to be so structured and rigid, and now I allow for more freedom and less planning.

Roben-Marie's Collage Journal Page Process

1. **Brush on a layer of gesso first.** *You might leave some areas a little thicker so you can add scratches or other markings into it. These markings will show through after paint is added.*

2. **Once the gesso is dry, brush some acrylic paints onto the page.** *I like the paint watered down a bit so it looks almost watercolored.*

3. **Use spray inks and stencils to add background images to your page.** *I will often go back and add more gesso to the page to block out some of the stencils, and then add more stencils.*

4. **Add layers of paper scraps or even a focal point image.** *You could use papers as a spot for journal writing. If working on loose pages, I will stitch around images or over the top of paper scraps. I also splatter paint over the layout if it needs some "messing up."*

5. **Keep layering stenciled images with paper until you like the results.** *I like to doodle around my images to make them stand out. Also, oil pastels will soften edges and blend things quite nicely. Use them with water or just smudge them on with your fingers.*

6. **Add journal writing in at the end or in layers between papers and paint.** *Sometimes my journaling is an art element and not a significant part of the page. Scan your finished journal pages so you can print and use them in your future work.*

started, and it is amazing that each time I do this, I pull out different items depending on my mood, and they all work well together.

Creating layers takes time and patience. You have to put in the time to create them, which is all part of the fun. Watching a piece evolve is quite exciting.

Today I am more confident and content to create what I like and what comes from my heart. I used to be so structured and rigid, and now I allow for more freedom and less planning. I don't worry about pleasing anyone but me, but I love that I can impact others by teaching them or providing inspiration to encourage them to trust themselves and create what they love.

Collage

MATERIALS

Substrate options: wood, canvas, cardboard, paper

Collage items of your choice

Attachment tools/materials: double-sided repositionable tape, Crop-A-Dile eyelet and snap punch tool, gel medium

Collage plays heavily into the artwork of Christine Mason Miller and Roben-Marie Smith. How about yours? You can use just about any substrate for collage, but you may need to try out different adhesives to see which work best on each surface. Using collage elements that hold meaning for you will help you hone your signature style. In one example here, I tore out a heart shape from one of my favorite scrapbook papers. Other options could include sewing patterns, sheet music and old book pages.

Here, we'll look at a few different methods of attaching and affixing collage items.

90

Tips

- I tear my collage papers, but you might also use scissors for clean, straight or decorative edges.

- I like to ink up the edges of a lot of the pieces I put down to make them look aged.

- I type up words that I like in fonts that I like to print out and use.

- Flip ahead to page 106. The red word "INSPI(RED)" on the upper right of my *Inspire* piece was from an envelope my friend sent (she circled it). It adds a personal little inside joke. I like to do this often in my art.

Gel Medium

I like to use collage for a lot of my backgrounds. Apply a layer of gel medium to the substrate first, and then stick down all of your collage elements. Put another layer of gel medium over the top to seal them in and make sure they're really tacked down. See the finished piece on page 90.

Eyelet and Snap Punch

Poke holes in the cardboard and paper with an eyelet-and-snap punch (I'm using a Crop-A-Dile). Use the Crop-A-Dile to set in eyelets. I like them because they look cool—and I get to use this tool and look tough!

Double-Sided Tape

Here I'm using double-sided repositionable tape to tack some elements down. What's nice about this tape is I can peel the collage element off and reposition it if I don't like how it looks.

You can also use collage as a central element in your pieces. See the finished piece on page 90.

Mary Ann Wakeley

It's hard to be specific when talking about my signature style and how it came to be. I rely on intuition and trust that what comes through in my art is what needs to. I hope that my contribution provides a positive impact on each person who comes in contact with it. I work very randomly, although there are a few things I do repeatedly throughout the entire process of working.

In the beginning of making a piece, I often will put the pastel right onto the wood. I select a color and go from there, blending it with a brush or my fingers. I rarely use two colors, one on top of the other; I like the strength of a single color and don't like to muddy it. I may take a wet brush to spread it around and let it seep into the wood. Or I might take some white acrylic paint and lighten the pastel color. This also lets me spread the pastel around and let it blend into surrounding areas.

I go back and forth with pastel, adding colors or blending with acrylic. I like to add lines with Conté crayon or charcoal. I may leave a line strong and on its own, or smudge the line, or add white to make it grayish and tone down the pastel. The whole process goes on and on in this way until I arrive at something that works to my eye.

I oftentimes spray an area with hairspray, which allows me to do further blending of colors. Depending on whether the wood is standing or laying flat, the colors may drip downward, creating another look. I may start out with the wood lying flat, which is what I do when working on small pieces. Larger ones tend to begin standing on an easel.

I also rotate the painting to see what emerges from viewing the piece from a different perspective. This is something I cannot do when I work on a large canvas tacked to the wall. I used to feel limited by this, but now I see it as a way to work more focused on what is in front of me.

The key is not to dictate how the piece should look. By being relaxed and happy with whatever happens during the entire process of painting or drawing, I am open to surprises that lead to trying new materials and methods of applying them.

Music is essential during my creative process. It helps form the energy of the painting and keeps it going. It also suggests

I rely on intuition and trust that what comes through in my art is what needs to.

the mood of the work. I listen to a variety of music when I work, so I may work on one part of the painting while hip-hop is playing, and then a classical piece comes on and helps me refine an area.

Music really feeds the painting and is what I think provides the visual depth. It draws out of me feelings that are translated using colors and lines, creating a visually musical work.

The Deep Within
Mary Ann Wakeley
Pastel, acrylic and Conté crayon on birch plywood
9" x 9" (23cm x 23cm)

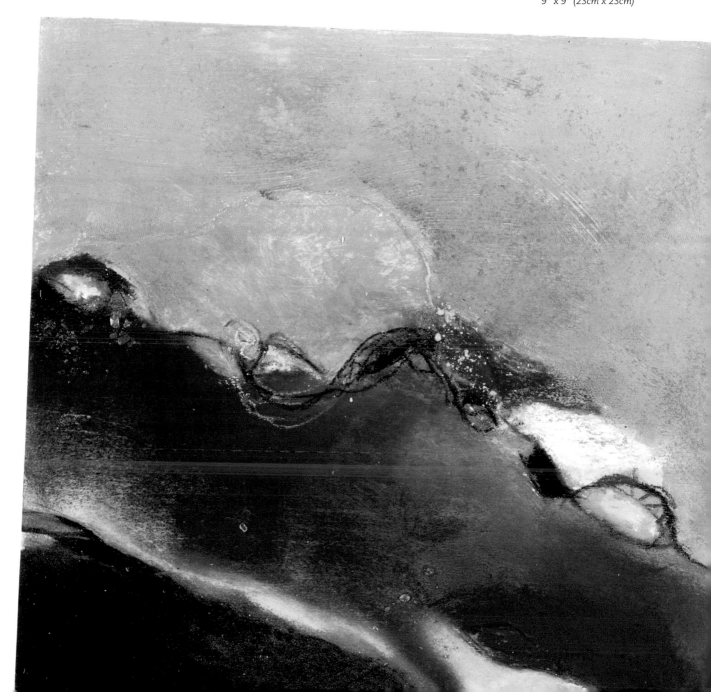

Julie Prichard

I see things and look into them. I stare at artwork and look at every layer, through every color. I analyze and study. I think to myself, "I can do that" or "I want to try that," and through trial and experimentation, I come up with my own interpretation of what I initially fell in love with.

Texture is an important ingredient to my artwork. I don't feel comfortable when a painting feels "flat" to me, so I attempt to incorporate some texture here and there. Although I am familiar with building texture with various mediums, most commonly I build it with paint. Painting with layers of acrylic paint offers the simulation of texture without having to add in heavy pastes and markings.

The start of my current artful journey was filled with one online tutorial or magazine tutorial after the other. My brain was a sponge, and I practiced every technique to familiarize myself with every product I could get my hands on. I studied supply lists and bought everything. I gathered coupons and used them all. I amassed so many supplies that I had trouble walking into my art space.

While all of this hunting and gathering was taking place, I was frustrated. It upset me that I was making paintings that looked like someone else's. My heart was not coming through into my work, although it was beating through my chest. None of those paintings were my own vision.

It took a lot of courage to stop reading tutorials, but I remember how great it felt. Finding my way, I started first with substituting supplies that I already had in my arsenal for those I didn't have on "their" lists. I taught myself how to create the same effects with the supplies I already owned, and I decided that I didn't need a specific brand name of a supply to make a piece of art. I went my own way.

I no longer read tutorials; I make them. I encourage my students to find their way by learning basic techniques that are applicable throughout their artistic expedition. I firmly believe that once you know the basics, you can turn the tutorials off and your true art voice will be heard.

It took a lot of courage to stop reading tutorials, but I remember how great it felt.

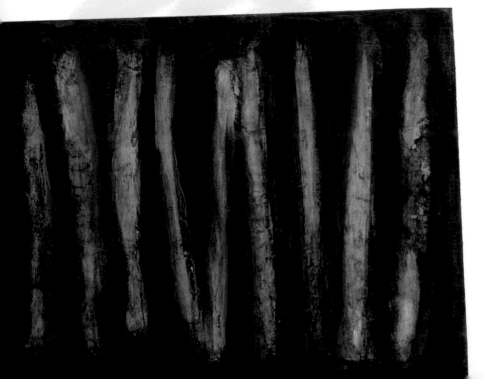

Nine

Julie Prichard

Golden fluid acrylics and Caran d'Ache Neocolor II Crayons on wood

8" x 10" (20cm x 25cm)

On Jupiter
Julie Prichard
Golden Fluid Acrylics on wood
10" x 10" (25cm x 25cm)

How to Add Texture to Your Painting

1. **Begin by applying paint more heavily in some areas of the painting than in others.** Using a scratch tool, make your mark in the areas that are a little bit thick with paint. Continue painting and layering while repeating with the scratch tool along the way. Try to scratch into every layer.

2. **To add even more texture, layer in Golden's Polymer Gloss Medium to the painting.** This medium is actually clear, and you can lay it on thick and thin while continuing to make your mark on the painting's surface. The medium will go on hazy, but it will dry perfectly clear. Do not rush drying.

3. **Once the last layer is dry, use washes of acrylic paint to highlight some of the peaks and valleys you have created with the scratching.** Thin washes of paint in darker or lighter hues than the color underneath will push back or reflect the texture you have created. Start with a little paint at a time until you have created the look you want. In this step, less is more.

Three Ways to Use Water-Soluble Crayons

Caran d'Ache Neocolor II Crayons are so versatile; I use them in different ways in every painting. They can be applied like a child's crayon or with water to behave like watercolors. You can:

Add them as accents. Create your painting and then add strokes of color on top of the painting with crayon. Your strokes might be writing or doodles.

Enhance some of your painting's colors with liquefied crayon. Add small strokes of dry crayon into the composition, and then paint over the crayon with a slightly damp brush. This will liquefy the crayon and make it look more like paint on the piece. The more water you add, the more subtle the crayon will be.

Create a "blur" of color. With a heavy hand, add lines of color to your painting after all of the paint has thoroughly dried. Then use a spray bottle to add a lot of water, letting the water pool over the crayon lines. Let the water sit until it dries; do not speed the drying process. Letting the water pool this way creates a cool effect that is more vibrant than a swash of watercolor paint.

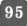

Work With Artist's Crayons

MATERIALS

Substrate of your choice (I used
canvas board and watercolor paper)

Conté crayons

Soft pastels

Water-soluble crayons

Paintbrush

Water-filled spray bottle

Hairspray or spray fixative

Playing with artist's crayons takes me back to child-hood. Sometimes it's fun to color outside the lines and explore what happens when you try different types of artist's crayons on different surfaces. Mary Ann Wakeley uses dry pastels and Conté crayons for color and line. Julie Prichard, on the other hand, prefers water-soluble crayons for adding color that blends in a more fluid way. Which will be your favorites?

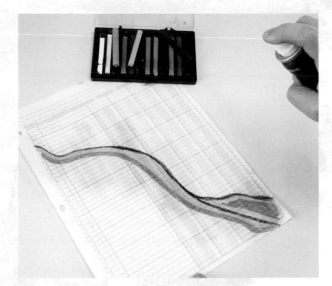

Conté Crayons

Use them on any dry surface. Seal the marks with hairspray and they won't bleed when you work more mediums over them.

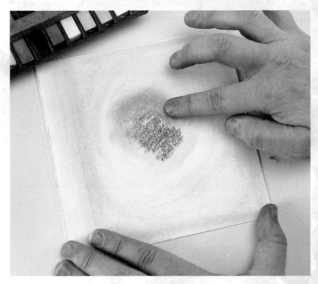

Pastels

Pastels are similar to Conté crayons but much softer. Blend them easily with your fingertip. Hairspray also works to seal pastels.

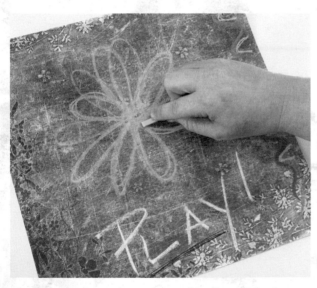

The opacity of Conté crayons makes them great for working on dark surfaces.

Different Crayons, Different Marks

A side-by-side comparison of the marks that can be made with a water-soluble crayon (left), Conté crayon (middle) and soft pastel (right).

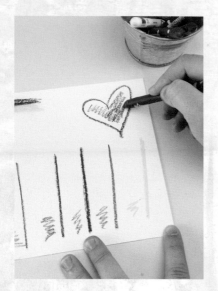 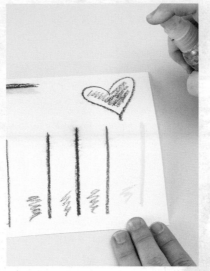

1 Draw with water-soluble crayons as you would with any type of crayon.

2 Spritz the marks with water. As soon as you get water on the marks, they start to bleed.

3 You can rub the pigment around with your fingers. The more you rub, the more it takes on the appearance of watercolors. If you want your lines to continue to show distinctly, don't rub hard. The more water you use, the more easily the colors blend together.

Tip

When working on paper—in a journal, for instance—if you rub too much, the paper will start to disintegrate. If you want to work more aggressively on paper, prep it with gesso first.

Water-Soluble Crayon Over Acrylic
You can work right on top of dry acrylic paint, activating your crayons with water as desired.

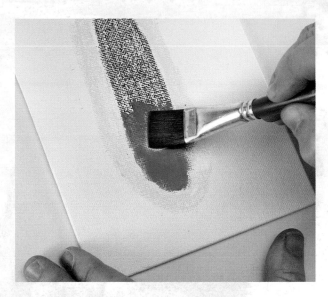

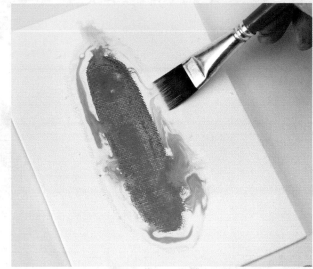

1 If you use a paintbrush to move the pigment around, you will maintain cleaner lines and delineations.

2 Draw shapes and soak them with water. Here, the first color bleeds into the border color.

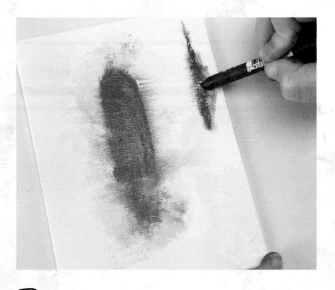

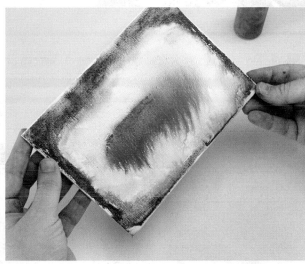

3 Try adding water to your substrate first and then work into it with the crayons. When done this way, your marks are less defined, and you get more of a watercolor effect right off the bat.

4 You can tilt your canvas on its side and allow the colors to bleed around.

Jenn McGlon

I've always considered myself an artist. It's all I ever wanted to be (besides the fashion world's next Betsey Johnson).

I began to evolve the most when I started really seriously trying to sell my art five years ago. I try very hard to not lose sight of my creativity and my true vision—a tricky thing when you are selling. It's quite easy to get caught up in what people want (or what you think or hope people want) and what truly is from your heart.

I've taken a lot more chances and have broadened my range of materials and designs. I've met bunches of fellow artists who inspire and encourage me to continue my dream. I've learned to share my ideas and art through my blog.

What gets my creative juices flowing? Vintage books (sometimes a random little phrase from an old book can inspire a whole painting!); old, chipped barn wood; old papers, letters and stamps; teeny antique bisque dollies; a pile of old buttons … and of course, some good music! Inspiration might be found in my

My House
Jenn McGlon
Polymer clay and acrylic paint
1" x 4" x 1" (3cm x 10cm x 3cm)

boys' sweet drawings, the text of an old French schoolbook, or the pattern on an old apron.

I think my painting style used to be more simplistic and primitive. Over the years, my style has become more layered and textured, and I have added new mediums like polymer clay to my work.

My go-to supplies include Golden gel medium (regular matte). I can't live without it for collaging. Perfect consistency,

perfect texture—it's perfect! I use Liquitex heavy body acrylics, and for painting fine details, I use Golden fluid acrylics. My teeny Fiskars scissors are good for precise and tiny cutting. Super Sculpey polymer clay is my favorite clay to sculpt with. It's easy to use, doesn't crumble and has a perfect smooth texture. I have tons and tons of scrapbook and vintage papers—major inspiration, color and patterns right at my fingertips. I also go to my vintage books for snippets of text and my big jar of vintage mica for when I need a sparkle fix. Plus, my music playlist—gotta have my jams—and a big cup of coffee. (I'm a busy mom of two boys, so I'm tired!)

I get giddy over the vintage supplies I use. The fact that they have a hidden past, a whole unknown life, completely excites me. Imagining the people who owned them before and giving these sweet items a new life and purpose is so fabulous.

I try very hard to not lose sight of my creativity and my true vision—a tricky thing when you are selling.

Delight

Jenn McGlon

Acrylic, old book pages and vintage fabric and buttons on stretched canvas

10" x 8"
(25cm x 20cm)

Play With Polymer Clay

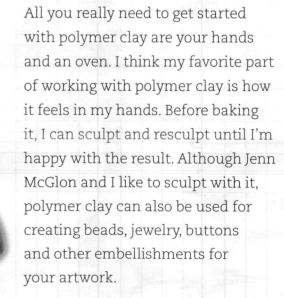

pure Muse

MATERIALS

Polymer clay
(I used Super Sculpey)

Clay sculpting tools
(or items such as a stick
or brush handle)

Fine-grit sandpaper

Sealant (I used Krylon spray)

Optional: Paper clip or wire,
acrylic paint

All you really need to get started with polymer clay are your hands and an oven. I think my favorite part of working with polymer clay is how it feels in my hands. Before baking it, I can sculpt and resculpt until I'm happy with the result. Although Jenn McGlon and I like to sculpt with it, polymer clay can also be used for creating beads, jewelry, buttons and other embellishments for your artwork.

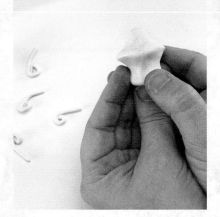 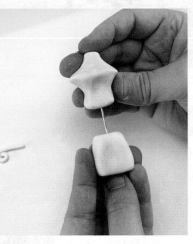

1 Soften up the clay, working and warming it in your hands. Begin shaping your pieces. There are all sorts of tools on the market that you can use to shape the clay, but I like to just use my hands.

2 If you have multiple large pieces that you'd like to connect, you can simply put in a piece of wire (or a paper clip) to attach the two pieces and make the link sturdier.

3 Cut details into your sculpture using a clay sculpting tool, paper clip, paintbrush, stick—whatever you have handy.

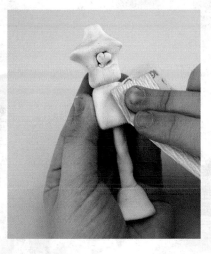

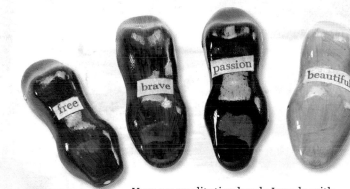

4 Follow the manufacturer's guidelines to bake your sculpture. After it cools, sand off any fingernail marks, thumbprints or nicks, and then paint and/or seal it any way you wish. I painted my sculpture with Golden fluid acrylics, and then sealed it with Krylon spray sealant. I chose to seal my sculpture because I added a collaged word to it. Sealing it just adds an extra layer of protection.

Here are meditation beads I made with polymer clay, each about 2" (5cm) long. I painted them with Golden fluid acrylics, collaged on meaningful text and sealed them with Krylon spray sealant to protect them.

Aimee Dolich

I've been hand lettering off and on for twenty years. I love the way it feels to shape a letter into being—it almost feels like carving to me. Pairing that with my writing has been another breakthrough in my own style. I love to write. But until the last couple of years, it never occurred to me to hand letter my own poems and thoughts; I always lettered someone else's quotes.

With two little girls in my charge, my schedule is usually on their clock, so creative time is limited. If I can get it together and use that time efficiently, that restriction actually can work in my favor. I have to get creative about being creative.

I am slowly training myself to do much of my creative play when I'm not actually making something. My doodles nearly always start with words, and I've found those words flow best while I'm driving. I keep a notebook in my car and my bag, and when I finally get to a stoplight or a parking lot, I scribble like a maniac in that book. When I have a spare chunk of time, my ideas are there, and I can get right to work on the lettering and drawing.

Longer stretches of time turn anti-creative on me very quickly. Unless I'm thoroughly immersed in a project, I have to break up big blocks of time into smaller chunks to keep myself on track, or I drift and dwell and waste time.

I start with things that amuse me or grab me unexpectedly: conversations in our household, things my children do, my ever-changing moods, overheard comments in public and so on. I'm fascinated by what goes on in other people's heads. I love finding remnants of human activity and wondering what prompts people to do what they do. I live in a college town where

Identity
Aimee Dolich
Gouache and ink on paper
11" x 8.5" (28cm x 22cm)

odd things are always going on. It's hard not to be inspired in a place where such an independent spirit thrives.

In the past, I compartmentalized everything, and I nearly always ran into a dead end because it was a very unsatisfying way to go about making art. My attempts at acrylic, watercolor, lettering, writing and craft projects were all isolated attempts—nothing crossed the borders of the others. I focused solely on technique and the end product instead of enjoying the process. I've let that all go. Now everything blends together, and it feels much more authentic to create.

I am slowly training myself to do much of my creative play when I'm not actually making something.

My lettering is all freehand. I pencil it out beforehand on my pre-inked backgrounds. Often I change my mind while I'm inking it in and change direction. I've found that the uneven, erratic style comes more naturally to me than traditional calligraphy; I can't get that kind of precision no matter how hard I practice. This is actually what I adore about hand lettering: You can put a pen in the hand of a hundred different people and tell them to letter the same word, and every result will be different.

I letter on paper, usually with black fine-tip Micron pens and sometimes with Rapidographs. Even though my fonts are uneven, I like a lot of control over my line. But you can use lots of different tools for hand lettering. Mine is one of many ways.

The concept of art seemed elusive and repressive to me for a long time because I focused constantly on what I didn't know or didn't have. When I realized I didn't have to look outside of myself to find my own style, I started to truly enjoy creating.

Aimee's Inked Backgrounds, Step by Step

For my backgrounds, I use mostly ink pads—any kind, ranging from inexpensive dye to lush pigment inks, dry to saturated. It is a quick, easy way to get a burst of color that requires virtually no prep.

1. **Put a piece of paper underneath your background paper.** *This will protect your work surface. Colors will spill onto that overflow paper, which you can then cut up and use for collage.*

2. **Turn the ink pad upside down and start rubbing it over your surface.** *Drier ink pads work best for cloudy effects; wetter ink pads are good for deep, saturated color.*

3. **Try various application methods.** *Touch lightly on your paper to capture the patterns and imperfections of the ink pad surface. Draw lines with the edges. Put crayon or wax resists underneath the inking to create texture. Combine it with watercolor. There really are no limits to this technique.*

This technique will work on anything that absorbs ink. Try it on untreated canvas, wood, ribbon, envelopes and picture frame mats. In most cases, you can brush on a later of acrylic finish so the color won't fade.

Tips

- *For journal pages, I use Moleskine blank notebooks. For illustrations and bigger lettering projects, I use hot-pressed paper, which has a smooth finish and prevents ink from bleeding.*

- *Sometimes I use watercolor instead of, or in addition to, the ink pads to color my backgrounds. I also use gouache, a thick and opaque paint, because I like the way it contrasts with the bright background ink colors and because it covers up my goofs.*

Hand Lettering

ND(RED) · EMPOWE(RED) · TREASU(RED) · CHEE(RED) · INC(RED)IBLE · ADMI(RED)
SHA(RED) · INC(RED)IBLE · ADMI(RED) · INSPI(RED) · ENAMO(RED) · ADO(RED) · SH
INSPI(RED) · ENAMO(RED) · ADO(RED) · SHA(RED) · KIND(RED) · EMPOWE(RED) · TRE

You stand in your own light, make it shine.

inspiration

MATERIALS

Substrate of your choice

Hand-lettering tools and
mediums of your choice

Your handwriting is uniquely yours. So why not use
it to create artwork that is unique, too? A smooth
surface makes lettering easier, so keep that in mind
if you want to add hand lettering to your artwork.
On a textured background, use a pen or marker that
will work well on the texture. On paper, results will
vary depending on the tool, so proceed by trial and
error. I love adding drippy inked text to my collage
paintings using India ink and a dip pen. You could
also try using a small paintbrush with thin acrylic
paint or paint pens.

Tips

- Like the background behind the Eleanor Roosevelt quote? Flip back to page 73 to see how to make it.

- Flip back to page 11 for more on pens and markers, and then try them out to find your favorites.

1 Draw letters.

1 This is the type of lettering I use most frequently in my artwork: drippy ink letters. Get a lot of ink on your pen (the more ink, the messier the result). Go slowly as you write your word; you can always go back over it if you need to. Put some pools of ink where you'd like to encourage it to drip.

2 Then embellish them any way you want.

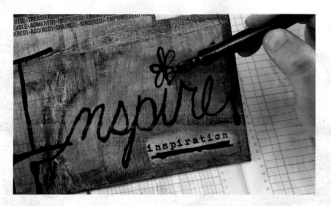

2 Tilt the piece straight up, tap it and allow the ink to drip. Then lay it down flat to dry.

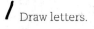

These began as printed letters. I went back with a pen and doodled up the left edges of their strokes.

3 Defining your Style

Playing with art supplies and exploring new techniques will begin to reveal bits of your signature style, but you're not alone if you still have some nagging feelings and uncertainties when it comes to declaring your unique style and owning the title of artist. Fear, the quest for perfection and our flippant inner critic often stop us in our tracks. Let's explore together some ways to work through those challenges so you can pour yourself into your artwork, take stock of your skills and embrace your own artistic uniqueness.

Putting Yourself Into Your Art

Whether you are just beginning your creative journey or are an experienced artist, you've probably found yourself completely engrossed in that creative space that is complete artful bliss. It's like a creative sweet spot, and you know it when you're there—and you don't ever want to leave.

As you playfully try new techniques, choosing colors and surfaces, you'll likely begin to see more of "you" in your artwork. Follow your intuition as you go, and allow yourself to let go of inhibition. I believe that as you begin to see bits and pieces of yourself in your work, your art really will begin to take on a unique style all your own.

I taught an online workshop called "Spill It!" that was the catalyst for this book. When I was trying to write a description for the workshop, what kept coming up was, "All the little things that make you unique will make your creative endeavors unique."

In that workshop, we explored a handful of mixed-media technique combinations, and I was blown away by what the participants were creating. When they poured themselves into their work, the results were unique and inspiring. The same can happen for you. As you determine the tricks of your trade, your creative voice will reveal itself.

In My Heart Today (journal page)

Roben-Marie Smith

Acrylic, spray inks, collage, stitching and oil pastels on paper

12" x 9" (30cm x 23cm)

Your Art Starts With You

We're all at different points in our lives and our art. When getting started, it can be tempting to get a jump-start by emulating the look of other artists, but going this route means that you miss out on an incredibly important part of the artistic process. What another person creates is an accumulation of her own perspectives and experiences, and the same goes for you.

Think about what is important to you: dreams, fears, goals, passions, special people and the bits of your everyday life that make you who you are. Let those things feed your art from within, rather than looking for inspiration from the outside. The journey might take you on a wild ride, but you will reap the rewards of staying on your own course. Discovering who you are is the best investment you can make in yourself. If you stick with it, you'll create a world for yourself that you'll never want to leave.

—Roben-Marie Smith

skill inventory

You may already have a whole arsenal of creative skills that are very much a part of who you are as an artist. Note what you're good at and enjoy doing, whether directly art-related or not. Maybe you already know the basics of watercolor or you love home decorating. Then, when you begin trying out the techniques in this book, you can work in some of your own ideas and skills to make the techniques your own.

I love making a mess. Although I didn't realize it when I first started painting, being messy would play a significant role in the development of my style. My artwork is often a mishmash of drippy paint with messy lettering and ripped papers. You, on the other hand, may have a knack for precision and organization, so your artwork may reflect that with defined shapes and clean images. My point? Use what you know. The more you acknowledge your skills, the sooner your style will emerge.

MAKE A CHECKLIST

1. Put a check in the box next to the skills you have.

2. Enter an "×" for the skills you would like learn.

3. Feel free to cross out the skills that don't appeal to you at all.

4. Write in your own creative, artistic and life skills that might help you in developing your signature style.

❑ **Doodling:** pencil, pen or marker on scrap paper or restaurant napkins, while on the phone

❑ **Fine art painting:** acrylic, oil and/or watercolor

❑ **Drawing:** sketching with pencil, pen or charcoal

❑ **Decorative painting:** craft paint, kids' watercolors or finger paints

❑ **Encaustic painting** (or even just playing with melted wax)

❑ **Photography** (Amateur or pro, it doesn't matter. You snap pictures everywhere you go, and you love it. Consider ways to incorporate your photos into your artwork.)

❑ **Scrapbooking:** combining photos with papers and multilayered items, creating collages and layouts

❑ **Home repair** (Think spackle, duct tape, hammer and nails, drippy faucet fixer. If you can fix stuff, you would probably be a natural at assemblage.)

❑ **Journaling:** either artfully or literally writing in a lined journal

❑ **Mess making** (Yes, this is a skill. Think spilled coffee, dripping ink, coloring outside the lines.)

❑ **Home decorating** (If you can decorate your home, you can decorate a canvas. You probably already have experience choosing color schemes, creating pattern and playing with textures.)

❑ **Fashionista skills** (Think layers. If you can layer clothes, you can layer paint and collage elements.)

❑ **Sculpting** (Even if only with Play-Doh! If you can work with that, you might make amazing things with polymer clay.)

Other skills I have:

Facing Your Fears

I'm usually not fearful of jumping right into things with both feet. For me, the fear sets in after I'm knee deep into something new. Once I've committed to the new endeavor, the gremlins start biting at my ankles, asking me what I've gotten myself into. And that all-too-common question comes up: "Who do you think you are anyway?" Then the fear comes and procrastination follows.

The blank canvas doesn't scare me nearly as much as the "almost finished" one. I have no problems throwing paint at a blank canvas. I know that if I don't love it, I can gesso right over it and begin again. I find comfort in knowing that I can start over when I'm painting.

I also take comfort in knowing who I can look to for support when I find myself needing to work through fear. I've learned that growth never happens when

What do you know now that you wish you had known then?

That you don't have to listen to other people's opinions, especially the negative ones. Taking on negativity has caused me some pain and suffering, all because I chose to believe another person over believing and trusting myself. I'm learning to trust myself now as an artist and creative soul.

—*Jessica Swift*

That it is OK to be exactly who you are. So what if no one else gets it? We're all guilty of running around, worrying about the innumerable ways in which we fail to measure up. Just imagine, though, how magical this planet could be if we all felt secure enough to be precisely who we are at this very moment. We would move mountains, my friends. We would.

—*Shari Beaubien*

Don't make comparisons to other artists. Keeping an art journal in particular is a personal journey and one that should be enjoyed. Discover your style and be inspired by others, but don't compare your journal pages with anyone else's. Be patient with yourself and enjoy the process.

—*Roben-Marie Smith*

I wish I had known that I didn't have to know everything. For example, I know that I'm still at the beginning in terms of artistic skill. I have a lot to learn. Ten years ago that thought paralyzed me from even starting a project; I felt like an impostor even walking into an art supply store. I was too focused on my own limitations, my lack of art credentials and experience, and it totally showed in what I produced. Accepting those limitations set me free—and in some cases I was able to break through some of them.

—*Aimee Dolich*

That approaching stores, galleries and people with my work is not a scary thing. There are far scarier things in life to face than sharing my artwork with the world. That was a huge lesson that I learned, as fear was my stumbling block. It can be intimidating, and it is normal to be hesitant to share our inner creations with the outside world. But as an artist once told me in response to my telling her why I had not yet begun to paint even though my heart longed to, "If you don't have a room filled from floor to ceiling with rejection slips, you're just not trying hard enough, dear." Those words totally shifted my perception. Rejection is an integral part of being an artist. It comes with the territory, and if you want to follow the artist path, then it needs to be embraced.

—*Bridgette Guerzon Mills*

I stay in my comfort zone; it happens when I reach out and ask for what I need. My confidence increases when I share my progress. Growth happens when I embrace vulnerability and risk showing others my artwork.

What about you? Where do your fears lie? Sometimes all it takes to face your fears is being aware of them, and then taking one small step forward. Make a mark on the blank page. Decide a piece of art is finished. Share your creative endeavors with a friend. Take action—one giant leap in with both feet or one tiny step at a time.

Be Prepared for Anything

Finding your own style means digging into yourself and finding out what is going on in there, as well as seeing things you haven't seen before. It's possible that your journey might be one exhilarating eureka moment after another, but it might not be, and that path is just as valid. You might come up against obstacles you didn't see coming, particularly if you feel like the artist has been coached out of you at some point in your life. That can be a tough mental hurdle to overcome.

Maybe you're a perfectionist. Maybe people around you don't understand your need to be creative. Maybe you run into a massive case of impostor syndrome. But none of this means that you're doing it wrong or that you should quit. In fact, it means that you've probably hit on something really important about yourself that you can turn to your advantage once you've confronted and drop-kicked that demon to the side. You'll savor those eureka moments even more when you know you've gotten past a challenge to get there.

—Aimee Dolich

The Secret Garden
Aimee Dolich
Gouache and ink on paper
10" x 8" (25cm x 20cm)

Embracing Imperfection

Making mistakes is normal. As you navigate new techniques, supplies and surfaces in your artwork, mistakes will happen. Often. It's part of the process. Try not to be too hard on yourself when they happen. The creative process is very forgiving; there is room for growth when mistakes occur. Sometimes they lead to new ideas or inspire a whole new approach to a piece. Torn papers, inky messes and dripped paint can become creative elements and opportunities for uniqueness.

One of the best ways to embrace vulnerability and risk imperfection is to try something new. As you approach each new technique in this book, do so with curiosity and the awareness that perfection doesn't exist in creativity. There really is no right or wrong way to create, but there is *your* way. And your way is neither perfect or imperfect—it just is.

Orange Tail Mermaid
Leah Piken Kolidas
Ink and watercolor pencil on paper
11" x 7" (28cm x 18cm)

The Seasons of Your Creativity

It's important to recognize that there is a unique rhythm to our creativity. There will be times when we're on fire with inspiration and making lots of art. And there will be other times when we're moving more slowly, feeling less inspired and not creating much.

I used to think I was doing something wrong during these slower periods, and I'd beat myself up about it. But over time, I realized that these down periods are just part of a cycle, just like the seasons, and they're perfectly natural. Once I accepted my creative winters, I began to enjoy them and used that time to replenish my creative stores by reading, exploring, gathering new supplies, wandering, doodling, dreaming, resting and playing.

Other times, I'm past the point of a down period and have moved into avoiding my creativity. When I catch myself wanting to do the dishes instead of paint, that's a good sign that I'm feeling some kind of fear around starting. When I can recognize the avoidance and fear, my favorite way to move through it is to get playful.

I love setting up something I call an "art picnic," where I spread out blankets and pillows on the floor, surround myself with art supplies and give myself permission to make "bad" art. By giving myself permission to just play, with no expectations, I can let go of my fears and begin to find my creative flow again.

—*Leah Piken Kolidas*

Silencing Your Inner Critic

I believe everyone has creativity within, and I also believe that in order for our creativity to be meaningful, it must be expressed. Sometimes our inner critic gets in the way of our ability to do so.

Ankle-biting gremlins. Energy-sucking vampires. Self-doubt monsters. Shaming super-villains. My inner critic is sometimes all of these, and usually a shape-shifter switching back and forth—biting my ankles, sucking my energy, shaming me and causing me to doubt myself every step of the way. Sometimes she even looks and sounds just like me.

I am often my biggest, loudest and most critical critic. Those voices in our heads—the inner critics in each of us—serve a purpose. They're trying to protect us, to keep us safe from harmful external judgment. But I've found my inner critic to be more hurtful than any comments I've received when I venture outside my comfort zone. Although the inner critic sets out to keep us safe, not only does it shield us from harsh judgments, it shields us from acceptance, praise and genuine connection.

It's important to acknowledge these voices, recognize what they're trying to accomplish and keep moving forward anyway. Stomp the gremlins, slay the vampires, pull the monsters out of the dark closet and knock out the super-villains the same way you tackle your fears—by facing them and taking one step forward. Create anyway.

And when they persist and just won't allow you to move forward, then draw them, paint them, write about them, talk to them, break out your art journal and illustrate them, sculpt them from clay. Use your evolving signature style to identify them so you can continue on your journey.

Listening to Your Intuition

My mannequin creations were an idea that came to me in a flash and spiraled outward in ways I could have never imagined. I was out shopping, saw a dress form in a window, and as soon as I got home, found an online mannequin retailer and ordered one. I had no idea what I was going to do or what the surface would be. I just followed my intuition.

Fast forward a few months, and less than an hour after finishing this piece, it sold, which ultimately led to a show and more mannequin art. This experience helped me realize that sometimes my intuition has even bigger plans for me than a single creation, and that the more I stay open to it, the greater the possibilities.

Remind yourself as you paint that no one needs to see it, approve of it, buy it, want it or need it; that whatever surface you are working on is your playground, a space where you are free to do and try whatever you want. Don't think, just paint. If you continue on the journey and want to improve your artistic skills, there will be a time when thinking will be a necessary and valuable part of the process, but in the beginning, just play.

—Christine Mason Miller

Rowena Murillo

For me, art is about the journey—the journey from blank page to finished project. The journey of mastering one's craft. But also the journey to the self. Using scraps of life, song lines and poems, old stories, dreams, memories, passing images and photos, I paint the internal landscape of this journey.

When I was a kid, I was always making something: a block tower or a Plasticine figurine or a collage of magazine pieces. My father was an artist, and my parents completely encouraged my creative yearnings. Art was fun and it was play, and I loved to do it. When I got older, I went to a specialized art high school and learned the basics of art and design, color and composition. I gained facility with art, but there was one thing I didn't learn until years later, and that was my purpose in art.

Art to me is the way I understand my world. It can be painting or journaling, poetry or fiction. Art is the way I answer my own questions and the way I give myself faith to continue on. It's the way I mark my life and find the beauty. I live my life and I make sense of it through my art. My art teaches me about how to live life, too, as I see metaphors and wisdom in the making of art. And as a teacher, I wish to help others discover the transformative power of art in their lives.

When I committed to being an artist as a teenager, getting an education in art in an art high school, "pretty" was my overriding impulse. I wanted to make things beautiful. I tried to make things look just like what I saw. I was learning my craft, and I wanted to make things look "right." When I went to college, I chose a non-art college, because after four years of art as school, I didn't want to study anymore. After only one semester, I discovered that art wasn't just something I did, but it was something that was a part of me. I was enchanted by the idea that art should show us the meaning of things, not just the surface. I was inspired by Neolithic art, Aboriginal art, art from the gut—like Frida Kahlo or Jean-Michel Basquiat.

Over the last seventeen or eighteen years, I have been trying to get closer and closer to representing the meaning of things instead of the thing itself. It has been important to me also to tell a narrative in many

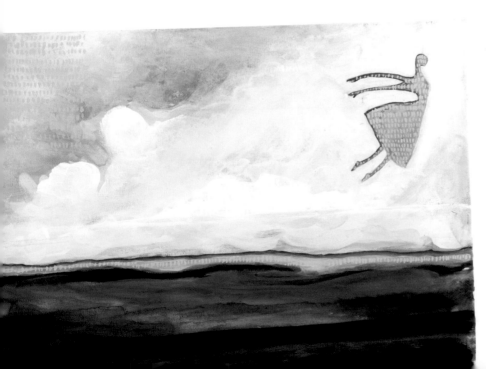

Flying Girl and the Day After, or The Journey
Rowena Murillo
Acrylic on watercolor paper
9" x 12" (23cm x 30cm)

I have found recently that my art has become almost like a journal on its own, as the paintings serve to document my journey symbolically.

of my paintings or to reference stories. I have found recently that my art has become almost like a journal on its own, as the paintings serve to document my journey symbolically. Sometimes the stories I paint, though, are part of the collective subconscious or a cultural zeitgeist. I have moved away from more realistic painting or drawing and toward a more conceptual art—sometimes abstracted, sometimes almost more cartoonish.

As I've grown, I've seen the things that I used to draw when I was a little child crop up in my paintings. The pretty ladies. Cross sections of houses. Or little saltbox houses. Trees. Fashion drawings. Cats. Superheroes. I like that the things I did for play have come back into my work. One of the things I've learned is that nothing ever dies with creativity. I can still pick up old techniques that I used and put them in a new painting with a new intention and it becomes a new thing. I can bring back an old image or idea and it takes on a new life.

I've been creative, my whole life, but it wasn't until I committed to a project, a continuing concept where I could explore meaning and technique, that I felt like a real artist. I spent a few years while I was pregnant and raising infants when I was completely uncreative. Committing to getting my creativity back after I had children and sharing that journey on my blog (www. warriorgirl.blogspot.com) was a big step in my development. I opened up to inspiration. I was actively searching out the creative process. I was looking for something to drive me.

The concept of painting every day scared me and drew me. I refused it, telling myself that I was too busy to paint a picture every day. I couldn't do it. But the idea stayed with me, and then one day the *Flying Girl* image came back to me, and I painted one. Then the next day I painted another. And every day after that I kept painting, and that went on without interruption for two or three months.

An interesting result of painting a new work every day meant that each individual piece was less important. I became less afraid to take chances and try new things, to risk ruining a picture and my concept of myself as "good." I could paint something I didn't like because the next day I knew I would be painting something new and I would have another chance. And the more I thought about what I was going to paint, what was coming next, what inspired me, the less I thought about the mistakes that I had made, or how I didn't have ideas, or maybe how I wasn't that good after all. All that mattered was the next step in the project, and then the body of work piled up behind me as evidence against the fear and insecurity.

Committing to my painting-a-day project allowed me to explore not only the things that I was painting, but also myself as an artist and my personal creative process. I learned to allow the "ugly" to happen, the bad phase of a painting when colors clash or the whole thing is just not right yet, so I could get through it to the finished work. Perhaps also to understand that each individual painting, no matter how successful, is still just another step in my own development and life.

STARTING WHERE YOU ARE: INTUITIVE JOURNALING

With intuitive creativity, no matter where you want to go, you have to start where you are. That can be a physical place or your emotional state.

Even if that place is full of anxiety—which being creative often is because it is risky, unknown, exposing yourself to the world—you need to recognize it for what it is. This is often where my work starts. I ask myself who I am, where in my life I am, what I need to hear, how I need to look at things, what is beautiful in that very moment, what is the thing that fills me with inspiration.

Journaling helps me to recognize this. I stop to write a list of beautiful thing,s or a page or two releasing my fears, or a few words acknowledging the things that move me. The journal allows me to collect these ideas, thoughts, images, inspirations and questions. If I don't write those things down, it is almost guaranteed that they will slip away. The journal also allows me to discover many things. The act of writing helps me to understand the moment.

MEETING THE PAGE REGULARLY: CREATIVE ROUTINE

Do not wait for inspiration to strike. The muse is a wonderful thing, but to really dive into your own creativity, you have to chase down that inspiration. Track down the muse in its wild habitat, your own life, and tag it and pin it into your journal for when you are ready to turn it into your art.

When inspiration does strike, draw small sketches in your journal. Mark down colors or feelings. Pay attention to the intentions of the moment because they may not be around when you are ready to paint. You need to show up to the blank page regularly, ready to be creative, ready to face the fears, and paint or draw or write. Even when you aren't filled with inspiration, you need to work anyway, develop your dependable routine, capture ideas and write about the questions and meanings of your life.

What does a dependable routine have to do with intuitive painting? It seems very unromantic to think that painting intuitively isn't about magic and inspiration on high. Well, it can be. It is a lovely thing to be taken away by the muse, but to do the real work of intuitive art means taking a long, extended trip into art, not just short jaunts now and again when the whim happens.

Part of the point of this way of doing things is to take the journey into the self. This is not the journey of one painting, but a body of work. This is not one day, but a life. This is about following the questions and inspirations, the mistakes and the successes. Even the lack of inspiration. It isn't about making the most beautiful painting every time. It is about facing down the fears and insecurities, and breaking through the barriers that you place before yourself so you can access your creativity honestly, so you can live your dreams.

FACING THE FEAR: LOWER THE STAKES

It doesn't matter how long I have been painting, how long I have been working on my creative process—there always comes a time when I am down and need to get back to my creativity. I take this now not as something wrong with me, which I used to think,

> *Do not wait for inspiration to strike. The muse is a wonderful thing, but to really dive into your own creativity, you have to chase down that inspiration.*

once upon a time. I understand that this is what it means to be an artist.

I am not less of an artist because I am afraid, or because I am uninspired, or because I paint ugly things sometimes. I am *more* of an artist because I keep coming back and facing the blockages, facing the fear. All artists face anxiety around their work. It is part of the process. But when you are still in a beginning stage—whether a beginning artist, or beginning a new phase, or beginning a new painting—the fear can take over and become blocks.

I don't believe in creative blocks. Blocks are just stepping stones to allow us to go higher.

Sometimes you have to lower the stakes of each painting. The daily painting helps in this, as each painting becomes less important when you have more of them happening. You can also try painting smaller. A 5" × 7" (13cm × 18cm) pad of paper can be a lot less intimidating than a huge canvas. Or perhaps try painting on a less intimidating material. Inexpensive newsprint can lower the stakes considerably to allow you to paint whatever your hand wants without worrying about "ruining" the work. Sometimes following someone else's prompt or picking a prompt word out of a hat can

reduce the importance of the work, since it's just a kind of game, trying to create according to the prompt.

Another technique that can lower the stakes of creativity is to work with one concept again and again. Pick an image or theme that resonates with you, something that perhaps you doodle, or something that you are drawn to, or something that you always have near you. Perhaps that is a self-portrait; the one model who is always with you is yourself. Perhaps an outline of your hand, waiting to be filled in with whatever meaning you desire. Perhaps the flowers that you have always doodled in the margins of your notebooks that want to be rendered in paint. Perhaps you love still lifes with bowls of fruit and vases. Or faces of pretty women.

If you find one theme, you always have something to paint. The only questions are what meaning you are going to give it that day, what colors you will choose, how you will explore the variations. This kind of constraint means that the anxiety of deciding what to paint can go away, and you can play freely within the boundaries.

The necessity here is to just get the creative muscles working again, even if you are not making

masterpieces. Because when the muscles start going, the inspiration follows.

TACKLING THE BLANK PAGE: JUST START

Sometimes when I paint, I have a concept in mind, but not an image. Perhaps it is a song line or a creative prompt. I look for colors that reflect the feel—soft or bold or mysterious or fun. Sometimes I have seen a picture of a landscape that captures my interest, and I might try to paint that. Or perhaps my kids have told me that they want me to paint a flower or an aquarium, and then instruct me on what colors to use. It's fun to release control of a painting in that way sometimes and just follow their instruction to see what happens.

Sometimes there is no idea at all. And yet, I know, even if my mind is blank in the moment, there is still so much under the surface that if I allow it, the art will come through.

After all the work in the journal and with the process and facing fears, in the end, you just have to start painting. It doesn't matter how you developed the ideas, whether they are found in that very moment or you have been drawing sketches and planning the painting for days. There comes a point where you must start.

Conclusion

I wrote the following poem in December 2008, just shy of one year after my creative journey began. Every line still holds true for me today, and I often have to take a moment to remind myself that all I have to do is start—over and over, as I grow and my creative style evolves. I hope that you too remember that to discover the unique artist within yourself, all you must do is simply begin.

FEELING TENDER AND VULNERABLE

Sometimes I sit and dream.

I think of all the things I'd like to do.

I put off the stuff that needs to be done,

trading that time for daydreams.

Thinking of conversations I'd like to have,

with old friends,

current friends and

with friends I've not yet made.

Wondering where the other people like me are.

How do I find them?

How do I connect?

I long to sit and laugh,

sip coffee, or hot cocoa, or tea,

while making a mess with art supplies,

or just chatting about nothing in particular,

or the meaning of life itself.

Deep conversations,

light conversations,

no conversation,

just being.

I don't want to *just* be a dreamer,

I want to be a doer.

I want to paint.

I want to write.

I want to take pictures.

I want to talk.

I want to listen.

I want to have a tribe of my own,

and be a part of the tribe of others.

I want to be a part of something bigger.

Something good.

Something powerful.

Make a contribution to the world.

Sometimes I think it's me that gets in my way.

Is it fear that stops me?

Lack of belief?

Lack of motivation or energy?

Lack of work?

I sit back and watch others do what I know in my heart I can do too.

Sometimes envious, or jealous, wondering what the secret is.

Wishing I could know what they know,

I cheer them on.

Pat them on the back.

Encourage.

Congratulate.

Sit in awe of.

Recognizing their potential,

their strength,

their capabilities,

their talent,

their accomplishments.

What is the missing piece?

How do I reach my full potential,

my strength,

my capabilities,

my talent,

so that I can realize and accomplish my dreams,

and contribute.

I suppose I'm not alone in my desires,

my dreams,

my paralysis.

I suppose the only way to find out is to "do" while continuing to dream.

I suppose I don't have to know how, I just have to start.

—*Carmen Torbus*

Meet the Artists

Karin Bartimole

I am a mixed-media artist working primarily in the realm of book arts. I paint, draw, collage and print. I think of book arts as interactive sculptures—interesting to look at as forms standing on their own, but longing to be experienced more fully by opening and paging through each layer of the piece. For me, the book is the most powerful, expressive art form I have worked in, creating an intimate journey that allows for close interaction with the viewer and art. Each page has the potential to deliver another level of expression on a particular topic through images, words and textures. For more, visit www.artsheal.com.

Shari Beaubien

When I was young and thumb-sucking was in vogue, I insisted that mine was grape. I've been happily inventing the flavors of my world ever since. Today, those flavors are bottled and sit stoically on my shelf in my Southern California studio—they are my beloved acrylic paints. Going to the office each day means I pad downstairs and contentedly splash color after glorious color across canvases of every shape and size. Sometimes wet and messy and other times more restrained, the rhythm of my process is like a dance all my own. I can't think of a single thing I'd rather be doing. For more, visit www.sharibeaubien.com.

Aimee Dolich

My professional background is in retail gift/stationery buying, product development and marketing. I loved working with product lines and the dynamic nature of the retail industry, but I needed more hands-on action. So I returned to my neglected creative side a few years ago and haven't looked back. I love the kicky high of an accomplishment or an exciting opportunity, but the more sustainable happiness arrives quietly and without fanfare from creating something every day—one doodle at a time. My husband and I live with our two girls in Lawrence, Kansas, a neat little college town just outside of Kansas City. For more, visit www.artsyville.blogspot.com.

Manon Doyle

For many years, I didn't know who I was or what I wanted out of life. I was creating art every day, but it was work that I thought would make others happy. I was lost with my work and lost in my life. In my late thirties, things slowly started to shift. I started to paint women in my journal. These women were strong, sensitive, happy, sad—and most had a message of hope. They spoke to my heart and showed me the way. Somehow through them, I discovered my artistic voice, but most importantly, I found me. I was born in Quebec, Canada, and have lived in many locations throughout Canada. I attended Cégep College in Quebec and Carleton University in Ottawa, where I majored in fine arts. I have sold my work in both the U.S. and Canada. My mosaics are on display at various locations in Scottsdale, Arizona, and my paintings are currently sold at Willow in Littleton, Colorado. I live in Dublin, Ohio. For more, visit www.manondoyle.com.

Bridgette Guerzon Mills

I am drawn to the inherent beauty and spirit of the natural world, and my artwork is a personal dialogue that reaches into the stillness of that spirit. Through both imagery and medium, I create organic pieces that speak to the cycles of life, growth and decay, memory and the passage of time. My mixed-media paintings incorporate moments captured by my original photographs with the richness of paint and a variety of mediums, creating a bridge between two worlds: the real and the reconstructed. I lay down layers of paint and pieces of photo transfers, papers or fibers on canvas to create depth in both form and meaning. This integration of diverse layers creates an intimate connection that invites exploration. My artwork aims to reveal the beautiful melancholy and the fragile imperfection of the life around and within. For more, visit www.guerzonmills.com.

Lynne Hoppe

I was born and raised in the Blue Ridge Mountains of Virginia but moved out West in my early twenties. At about the same time, I realized that I didn't really know who I was, so I set off on a path of self-exploration that continues to this day. I've been a mother, a forester, a sales clerk and a special education teacher, among other things. Throughout it all, I've been a lover of nature, a reader of books and a maker of stuff. Painting knocked at my door when I was fifty, and I welcomed it with open arms! For more, visit www.lynnehoppe.blogspot.com.

Mystele Kirkeeng

I am knit together to encourage—to give courage to others and to create. When I am being who I'm meant to be, I am more alive to God, more present in life, than in any other daily occupation. I've always been creative—pretending, playing piano, singing, writing, performing, nesting, making—but it took an honest admittal of on-going depression to unearth the painter in me. Today, I find myself in the midst of a most beautiful awakening. Don't get me wrong—I still struggle with depression, but it doesn't define who I am. Painting has become my way to mark how God carries me out of my Egypts and gives me increasing courage to embrace true freedom in this life. Day after day, I am amazed at what I've been given to give away—an art-full Life. For more, visit www.mystele.com.

Leah Piken Kolidas

I grew up on the North Shore of Massachusetts. From the age of two, I was drawing constantly. I graduated with a BFA from Massachusetts College of Art and Design in 1999 with distinguished honors. I have worked as a mural artist and a museum manager, and I've done creative work in graphic and Web design. Besides painting, I love reading, writing, collecting odds and ends for collages, drinking hot chocolate and laughing loudly. I live near Boston with my husband and our four cats.

My art is like a visual puzzle where layers of seemingly unrelated images are collaged together to tell a story. Much of my art involves telling the stories of women through exploring the symbols and experiences that call to be expressed. In telling these stories, I find I'm telling my own story, and others often find their own meaning and connection in the pieces. For more, visit www.bluetreeartgallery.com.

Jenn McGlon

I am a self-taught artist and love to create all sorts of funky things for Noodle and Lou Studio. I love polka dots, funky women with striped tights, hearts, birds, houses, couples—and they all make a lot of appearances in my work. I live in the suburbs of Chicago with my two sons, Jake and Henry (aka Noodle and Lou), my husband, Chris, and my cat, Mazzy. My collage artwork and "lulette" sculptures are always cheerful and full of whimsy. For more, visit www.noodleandlou.blogspot.com.

Christine Mason Miller

I am a Santa Monica-based writer and artist who has been creating, writing and exploring ever since I was a little girl. My mission to inspire has provided the foundation for all of my creative work. The desire to encourage others to pursue their passions and create a meaningful life is the common thread throughout an expansive body of work that includes mixed-media collage, commercial illustration, photography, writing, teaching and speaking. My art and writing give viewers a peek into a variety of details from my life, details that grab my attention on journeys around the world as well as within myself. Using materials as varied as acrylic paints, ink, coffee, mannequins, vintage photographs and other ephemera, my creations are full of color, texture and hidden stories. For more, visit www. christinemasonmiller.com.

Rowena Murillo

My earliest memory of art is a Degas print I had in my bedroom when I was five. I was destined to either be a ballerina or an artist. Seeing as I never took a dance lesson, art it was. Since then I have been fascinated with all sorts of things—graceful women, trees, houses, the sky, miniatures, prehistoric art, science fiction, fashion, animal spirits, geology, the collage of NYC, birds, cats, mythology, genetics, hands, words, Shakespeare, children's books, dreams, fairy tales, poetry, ladders, basements, blueprints, tarot, superheroes, monsters and pretty much almost every-thing that has crossed my path. This curiosity has served me well in my pursuits of art, writing, teaching, design and spirituality. Everything feeds into everything else. For more, visit www. warriorgirl.blogspot.com.

Julie Prichard

I was born and raised in San Diego, California. When I was a child, my mom towed me to art stores to explore wondrous art supplies. But it wasn't until high school that my creative urge was truly awakened by an inspiring photography teacher. Receiving a few local awards prompted me to seek a profession that was equally creative and fulfilling. I obtained a degree from the Gemology Institute of America that not only included the grading of gemstones, but gave me an appreciation of the natural beauty of gems and their artful transformation into pieces of jewelry. My professional time as a gemologist came to an end with the birth of my daughter, an event that saw the beginning of my career as an artist. Now she and I go exploring the aisles of artist supplies together as I once did many years ago with my mom. For more, visit www. julieprichard.com.

Roben-Marie Smith

I might still be plugging away as a public relations consultant had the charm of mixed-media collage not lured me away a decade ago. Instead, I spend sun-filled days enjoying the panoramic view from my studio in Port Orange, Florida, surrounded by paint, glazes, papers, ephemera and rubber stamps from my own line, Paperbag Studios. I draw much of my inspiration from the art materials themselves, creating my own markings with lids, sticks and other serendipitous tools. I thrive on making and working in art journals, which I consider individual collages.

Sharing my art in publications and teaching at stores and artistic gatherings throughout the country keeps me on the go. I am also very involved with my church and assist my husband of twenty years as we work with the teenagers weekly in our home. For more, visit www.paperbagstudios.com.

Jessica Swift

I am a full-time artist, surface pattern designer, illustrator and painter. I'm interested in color and the way images speak and capture truths and feelings that words simply can't. I believe we are visual creatures, and we crave worlds filled with sights and images that make us feel joyful. I believe we are meant to do what we love, to feel joy. I'm blessed to be a full-time artist and graphic/surface pattern designer; I'm truly living a life that I love. I'm interested in connecting our eyes to our hearts, and I believe that's done through images.

I live in Atlanta, Georgia, though I grew up in Boulder, Colorado, and went to college in upstate New York. I have a BFA in painting and a minor in French. One day I will use that minor when I own a houseboat in Amsterdam and visit Paris regularly. For more, visit www. jessicaswift.com.

Mary Ann Wakeley

I was born in 1961. I am an artist who paints and draws feelings in mixed media. Relying on my intuitive ability, I trust that what comes through in my art is what needs to come through. My methods and styles progress yet circle back and come forward again in a new way, giving a sense that I am drawing on some past experience but am presenting it anew. I am not an artist who stays stuck in a moment. My key themes are harmony, understanding, transformation and progression. A lover of nature and beautiful and mysterious things, I take inspiration from music and ideas researched through my pursuit of higher knowledge. For more, visit www. maryannwakeley.com.

About the Author

I am a self-taught mixed-media artist and workshop leader. My workshops combine mixed-media techniques with enthusiasm, passion and participant perspective. I strive to create experiences and art that encourage connection, validate emotion and nourish the soul. My artwork and blog have been featured in *Somerset Studio* and *Artful Blogging* magazines. I'm a bliss follower, big dreamer and lover of the words, "I'm so inspired right now!" You can find me online at www.carmentorbus.com.

RESOURCES AND FURTHER INSPIRATION

Websites
www.etsy.com
www.CreateMixedMedia.com
www.crescendoh.com
www.creativeeveryday.com
www.springinspiration.com
www.kindovermatter.com

Manufacturers
Golden Artist Colors
www.goldenpaints.com

Liquitex
www.liquitex.com

Ranger
www.rangerink.com

Magazines
Artful Blogging

Somerset Apprentice

Cloth Paper Scissors

Somerset Studio

O Magazine

Books
Spilling Open: The Art of Becoming Yourself by Sabrina Ward Harrison

The True and the Questions: A Journal by Sabrina Ward Harrison

Altered Surfaces: Using Acrylic Paints With Gels, Mediums, Grounds & Pastes by Chris Cozen

The Creative Entrepreneur: A DIY Visual Guidebook for Making Business Ideas Real by Lisa Sonora Beam

Ordinary Sparkling Moments: Reflections on Success and Contentment by Christine Mason Miller

The Artist's Way by Julia Cameron

The Journal Junkies Workshop by Eric M. Scott and David R. Modler

The Non-Planner Datebook by Keri Smith

Mess: The Manual of Accidents and Mistakes by Keri Smith

The Gifts of Imperfection by Brené Brown

Kaleidoscope: Ideas & Projects to Spark Your Creativity by Suzanne Simanaitis

Mixed Emulsions: Altered Art Techniques for Photographic Imagery by Angela Cartwright

The 12 Secrets of Highly Creative Women: A Portable Mentor by Gail McMeekin

Secrets of Rusty Things: Transforming Found Objects Into Art by Michael de Meng

Living the Creative Life: Ideas and Inspiration From Working Artists by Ricë Freeman-Zachery

Creative Awakenings: Envisioning the Life of Your Dreams Through Art by Sheri Gaynor

Caffeine for the Creative Mind: 250 Exercises to Wake Up Your Brain by Stefan Mumaw and Wendy Lee Oldfield

Online Workshops and Retreats
Mondo Beyondo
www.mondobeyondo.org

Dirty Footprints Workshops
www.dirtyfootprintsworkshops.com

The Land of Lost Luggage Workshops with Julie Prichard and Chris Cozen
www.julieprichard.com/mixed-media-workshops

The Purple Cottage Retreats
www.thepurplecottage.com

Index

Indulge your creative side
with these other F+W Media titles

CREATIVE AWAKENINGS

Sheri Gaynor

Begin your own creative journey with an overview of the intention-setting process. Be introduced to twelve artists who went through the process themselves, and see firsthand how they used it to realize their own dreams. Use the interactive bonus deck of tear-out prompt cards to help set your own intentions and record the process in your own journal.

Paperback, 8.25" × 10", 152 pages
ISBN-10: 1-60061-115-X
ISBN-13: 978-1-60061-115-5
SRN: Z2122

INNER EXCAVATION

Liz Lamoreux

There are clues all around you—sounds, textures, memories, passions—just waiting for you to shine a light on them, and unearth the most intimate form of expression—the self-portrait. Prompts and exercises will show you how to express who you are through the photos you take, the words you write and the art you create.

Paperback; 8" × 10", 144 pages
ISBN-10: 1-4403-0309-6
ISBN-13: 978-1-4403-0309-8
SRN:Z6885

TAKING FLIGHT

Kelly Rae Roberts

Find your artistic wings through inspiration and techniques that will make your creative spirit soar! You'll learn, step-by-step, 28 of the author's and contributing artists' favorite techniques and ways that they can be applied to your own personal artwork. Along the way, be inspired by thoughtful prompts, meaningful quotes, and stunning visual imagery.

Paperback, 8" × 10" , 128 pages
ISBN-10: 1-60061-082-X
ISBN-13: 978-1-60061-082-0
SRN: Z1930

www.CreateMixedMedia.com
The online community for mixed-media artists

TECHNIQUES • PROJECTS • E-BOOKS
ARTIST PROFILES • BOOK REVIEWS

For inspiration delivered to your inbox and artists' giveaways, sign up for our FREE e-mail newsletter.

These and other fine North Light Books titles are available from your local craft retailer, bookstore, online supplier, or visit our website at www.ShopMixedMedia.com.